# Painting Expressive
# Pastel Portraits

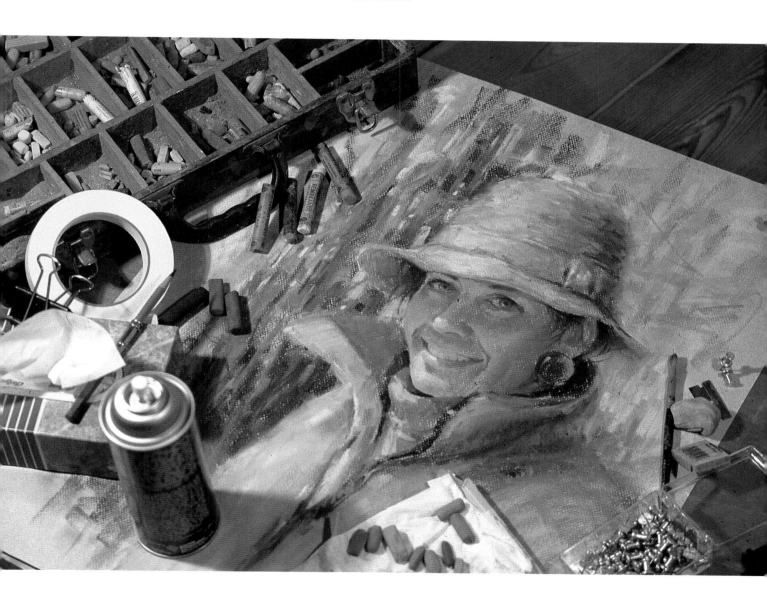

## PAUL LEVEILLE

NORTH LIGHT BOOKS
CINCINNATI, OHIO

## ABOUT THE AUTHOR

In his studio nestled in the hills of western Massachusetts, Paul Leveille paints the portraits of nationally and internationally distinguished clients. He has been pursuing his love of portraiture since 1980. Prior to that, he spent twelve years as an art director and illustrator in advertising. He is a graduate of the Vesper George School of Art in Boston.

In addition to his portrait commissions, Leveille teaches portrait painting workshops and conducts portrait demonstrations around the country. He has also produced a seventy-minute instructional video entitled *Portrait Demonstration in Oils* and is the author of *Drawing Expressive Portraits* and *Painting Expressive Portraits in Oil*, both published by North Light Books.

Leveille is a member of the Copley Society, Boston; the Academic Art Association of Springfield, Massachusetts; the Springfield Art League; The Rockport Art Association, Rockport, Massachusetts; the Connecticut Pastel Society; the North Shore Art Association, Gloucester, Massachusetts and the Pastel Society of America. He resides with his wife and daughter in West Holyoke, Massachusetts.

**Painting Expressive Pastel Portraits.** Copyright © 1998 by Paul Leveille. Manufactured in China. All rights reserved. No part of this book may be reproduced in any form or by any electronic or mechanical means including information storage and retrieval systems without permission in writing from the publisher, except by a reviewer, who may quote brief passages in a review. Published by North Light Books, an imprint of F&W Publications, Inc., 1507 Dana Avenue, Cincinnati, Ohio 45207. (800) 289-0963. First edition.

Other fine North Light Books are available from your local bookstore, art supply store or direct from the publisher.

02   01   00   99   98      5   4   3   2   1

Library of Congress Cataloging-in-Publication Data

Leveille, Paul
    Painting expressive pastel portraits / by Paul Leveille.—1st ed.
       p.    cm.
    Includes index.
    ISBN 0-89134-815-8 (hardcover : alk. paper)
    1. Portrait drawing—Technique. 2. Pastel drawing—Technique. I. Title
NC880.L46   1998
743.4'2—dc21                                      98-6131
                                                     CIP

Edited by Jennifer Long
Production edited by Marilyn Daiker
Designed by Mary Barnes Clark
Cover illustration by Paul Leveille

# ACKNOWLEDGMENTS

Over the years, not one of my workshops has gone by without students asking me, "When will you do a pastel book?" This book has been completed as a result of their constant asking, pushing and encouraging. Thank you all!

Special thanks is in order to my mother-in-law, Mary Mitchell, for her dogged persistence in translating the reams of my yellow pad "hen scratching" into legible prose.

And finally my deepest appreciation to my editors Pamela Seyring and Jennifer Long for their understanding patience and encouragement.

# TABLE OF CONTENTS

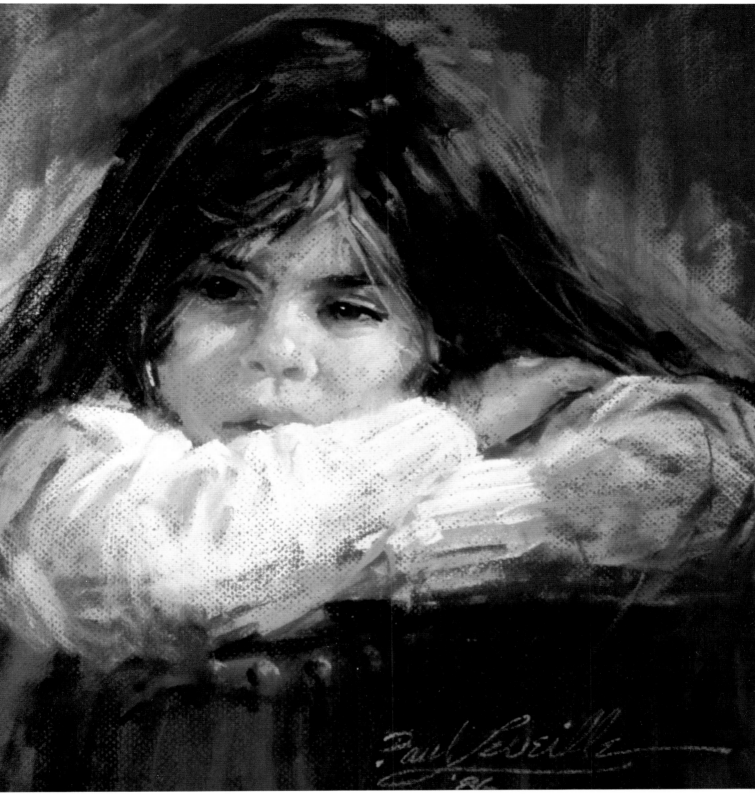

## DAYDREAM
*Pastel on Canson Mi-Teintes tobacco (patterned side), 16" × 20" (40.6cm × 50.8cm)*

*Choosing "the road less traveled" for this portrait of my daughter turned out to be a good decision. Ordinarily, I would have chosen a cream or ivory paper to contrast with her dark hair. For this situation, however, I decided to try a dark brown paper. While the light, warm tones of her face are framed by her dark hair, the whites and blues of her sweater have been repeated in the background to bring the figure forward and create a pleasing design.*

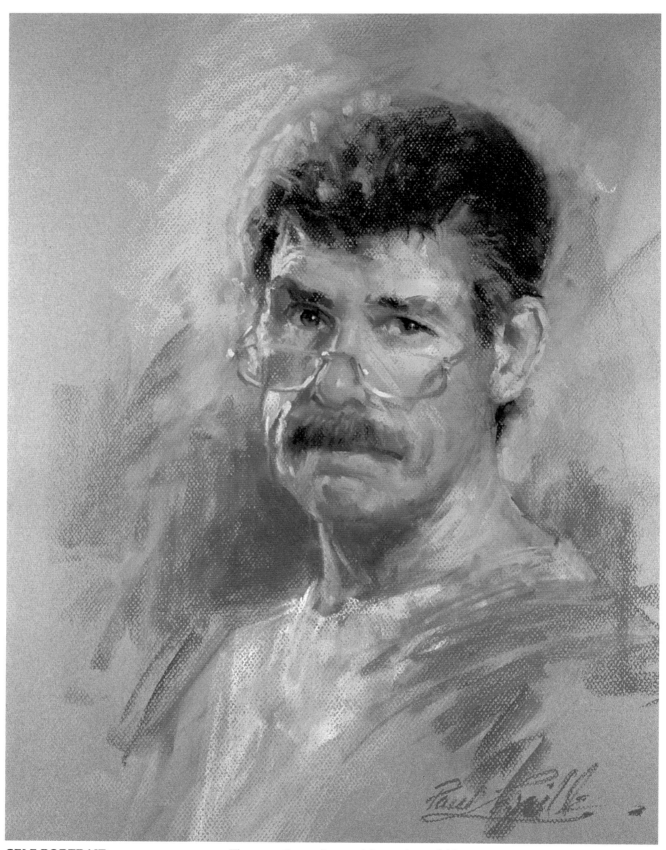

**SELF PORTRAIT**
Pastel on Canson Mi-Teintes steel gray
(patterned side), 17" × 22"
(43.2cm × 55.9cm)

*There are times when models aren't available. Guess who always is? I painted this portrait using a mirror. A warm, incandescent bulb was the main light source. The thin, cool light on one side of my face came from my northern-lit windows and added interest and a challenge to the pose.*

Years ago there was a TV series called *Route 66*. It focused on the adventures of two young men as they traveled across the country via Route 66. Although their destination was to reach the other side of the country, their main purpose was to learn from the experiences, people and places they encountered along the way. We may all have different goals and destinations regarding our painting. However, I think we should all keep in mind that it is not the arrival but the *journey* that is the joy. If, while traveling the art path, this book creates excitement and a desire in you to paint more portraits in pastel, then I have met one of my goals. I feel that if you have a strong desire to do something, you will do more of it. The more painting you do, the more you will improve. In between the excitement and the joy of painting pastel portraits, you may fall. So what? We all do. Pick yourself up, dust yourself off, and get on with your journey.

Wishing you a great trip!

Paul Leveille

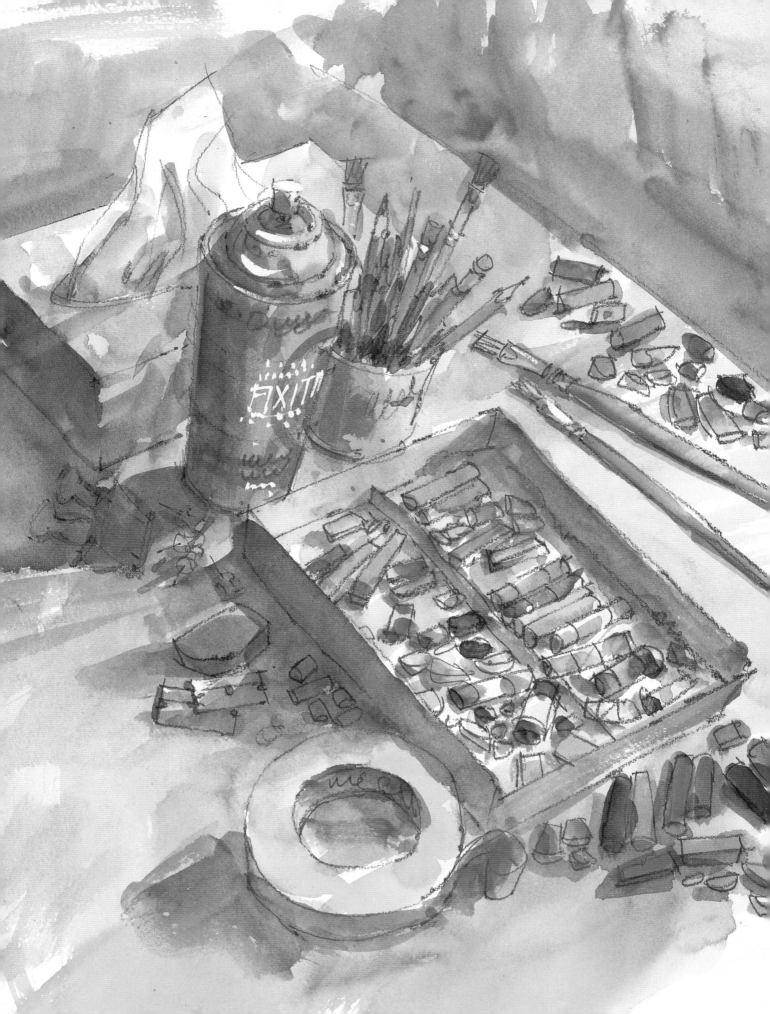

# 1 Materials

No doubt you've heard the expression "clothes make the man." I can see where a new outfit may give a person more confidence, a lift in spirit and attitude. However, fine clothes won't increase their intelligence, their ability to perform certain tasks or their skill level. Likewise, using quality materials for painting in pastels will not automatically make you a better artist. However, using good materials can make your painting experience more enjoyable. The more pleasure you get from painting, the more of it you will want to do; the more you do, the more you will learn.

With today's renewed interest in pastels, there is an abundant variety of pastels, equipment and surfaces from which artists can choose. In this chapter I will discuss the pastel materials I've found most helpful. I hope they will work for you as well.

## PASTEL COLORS

Although the color names of pastels are often labeled on the box—or on a paper wrapper for some soft pastels—the sticks seldom find their way back into the same order in the box and the wrappers are soon discarded. My pastels are a jumbled assortment of full sticks and broken pieces, grouped together by color family. When I want a certain color, I simply look through my collection to find the one I need; the actual name of the color is of little consequence.

For the demonstrations in this book, I've tried to describe the nature of the color I'm using in each step (such as a cool, light pink), rather than give it a specific name. To further aid you in selecting colors, each demonstration also contains a photograph of the pastel sticks I used for that portrait.

## PASTELS

Since I'm always looking for a new pastel color, I can't resist purchasing a few individual sticks whenever I stop into an art supply store. As a result I have an assorted collection of pastels that include the following brands.

Most of my paintings are executed with *Rembrandt, Grumbacher* and *Holbein* medium soft pastels. *Sennelier, The Great American Art Works* are very soft pastels that are wonderful for final creamy strokes and highlights.

Soft pastels are usually made up of pigment, chalk or clay and a binder (gum tragacanth). While wet, the mixture is shaped by hand or machine into sticks. Some brands of pastels are round or tubular, while others are four-sided sticks.

While I paint almost exclusively with soft pastels, hard pastels such as *Nupastels* come in handy at times. Hard pastels have more binder in them so they crumble less. Because of their hardness, they can be sharpened to a fine point with a razor. They are most useful for sketching at the beginning of a painting or for detail areas. However, they do not go on easily over areas of a painting already built up with soft pastels.

## PASTEL SURFACES

I prefer to use paper for my pastel paintings. I like the give or bounce when I apply different degrees of pressure with a piece of pastel. Some samples of the type of paper I use are shown on page 19.

## EASEL

Since I like to stand when I paint, a studio easel is ideal for holding my painting in a vertical position at eye level. It allows me to move away from the painting quickly to get an overall perspective. If you prefer to sit, a drawing table that tilts works well.

## DRAWING BOARD

A piece of one-quarter-inch lauan paneling makes a good, lightweight drawing board. Most lumber yards carry this paneling, and they can cut it for you; or, if you prefer, you can cut it yourself to a convenient size with a mat knife. I clip fifteen to twenty sheets on a board. This gives a good, padded surface to work on.

## CLIPS

Clips come in various sizes. I use the large two-inch clips to hold my paper to the drawing board.

## PAPER GUTTER

Save your studio floor by attaching a paper gutter to the bottom of your drawing board. To make one, simply fold a piece of paper (newspaper works well) in half, each side about three inches high. The gutter should be a little wider than the width of your drawing board. Next, tape the ends together. Now you can set your drawing board and attached drawing paper into the gutter and secure them on your easel. The pastel pieces and dust that break loose while you are working will fall into the gutter, not on the floor.

## MASKING TAPE

Masking tape is very handy. In addition to being used to attach or mend items, it can be used to remove unwanted areas of pastel from your painting. Just apply the sticky side of the tape to the desired area, push and lift—much like removing lint from your clothing.

## TISSUES

When working in pastel I always have a tissue in my left hand, ready to wipe my pastel stick clean after every stroke. When a mark is made with a pastel stick, it not only leaves color on the surface, it also *picks up* some color. A quick wipe with a tissue keeps it clean. Tissues also come in handy for blending large areas of pastel.

## PUMICE

Pumice is a fine grit powder made from crushed stone, available in most hardware stores. Pumice is traditionally used in refinishing furniture, but is also handy for rejuvenating overworked areas in pastel paintings.

## RAZOR BLADES

Single edge razors can be purchased at most paint stores and are very handy for sharpening points on hard pastel sticks.

## BRISTLE BRUSH

A good hog hair oil painting brush can be very useful for brushing pastel from overworked areas of a pastel painting.

## FIXATIVE

I never spray my final painting with fixative since it can change the values drastically. However, if I start my painting with a charcoal sketch, I will spray the sketch before continuing with pastel to prevent smudging. A light spray of fixative can also add a little more "tooth" to a slightly over-worked area of a painting. If an area in the painting gets *too* overworked, I brush off the pastel in that area and give it a light spray of fixative. While still wet, I sprinkle pumice over it and add a final spray of fixative to cause the pumice to stick.

## KNEADED ERASER

Work a kneaded eraser by pulling and squeezing it with your fingers until it becomes soft. You can then use it to remove pastel from your painting by pressing it to an area of the painting and lifting. This technique can also be used to produce highlights.

## TORTILLIONS

Tortillions are made of soft felt paper, rolled and pointed at one end. They are useful for blending and softening edges when working with pencil, charcoal or pastel.

## PROTECTIVE HAND CREAM

Removing pastel from your hands, under fingernails and cuticles can be difficult. I use a protective hand cream before painting. When finished, I wash my hands with soap and water, and the pastel comes off easily. Paint, garden and hardware stores carry this type of product under names such as Invisible Glove, Liquid Glove, etc.

## LATEX GLOVES

Latex gloves can be used to protect your hands from pastels while still allowing a sensitive touch.

## WIRE HANGERS

Because pastel paintings smudge easily, storing them safely can be a problem. One solution is to hang them from wires. In a corner of my studio, I've stretched parallel wires about three feet long. They are spaced about fifteen inches apart. Each wire holds about twenty small clips from which my completed pastels are safely hung side by side.

## MATTING AND FRAMING

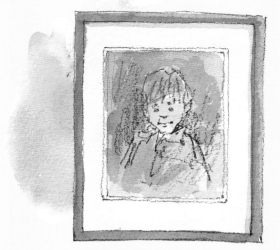

PASTEL FRAMED WITH MAT

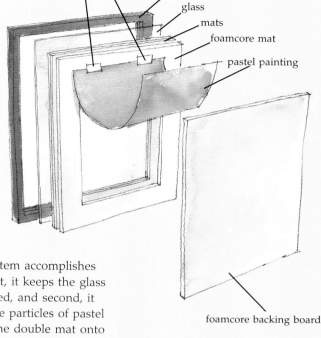

When framing pastels, it's a good idea to keep the painting from touching the glass by separating them with a mat. For my pastels, I prefer to use a double mat backed by a thicker foamcore mat that is narrower on all sides, making it invisible when the framing is completed. This system accomplishes two things: First, it keeps the glass and art separated, and second, it allows any loose particles of pastel to fall behind the double mat onto the unseen foamcore mat, rather than onto the cut edge of the mat.

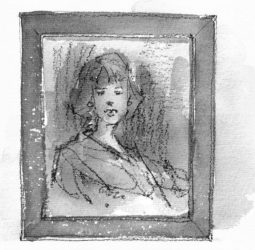

PASTEL FRAMED WITHOUT MAT

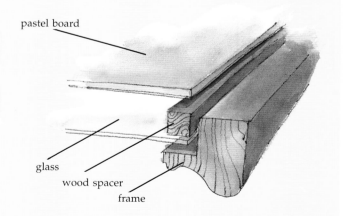

Pastels can also be framed without a mat, using a method similar to framing an oil painting, where all sides fit to the sides of the frame. I find this method easier to accomplish if the pastel painting is done on a hard surface, or the pastel paper is pre-mounted on a hard surface. A wood spacer is used instead of a mat to separate the pastel from the glass. The spacer can be made up of ⅜″ × ⅜″ (0.95cm × 0.95cm) strips of wood. After the glass is fitted into the frame, the wood spacers are then glued or tacked into the rabbet of the frame. The pastel painting is then positioned into the frame over the spacers.

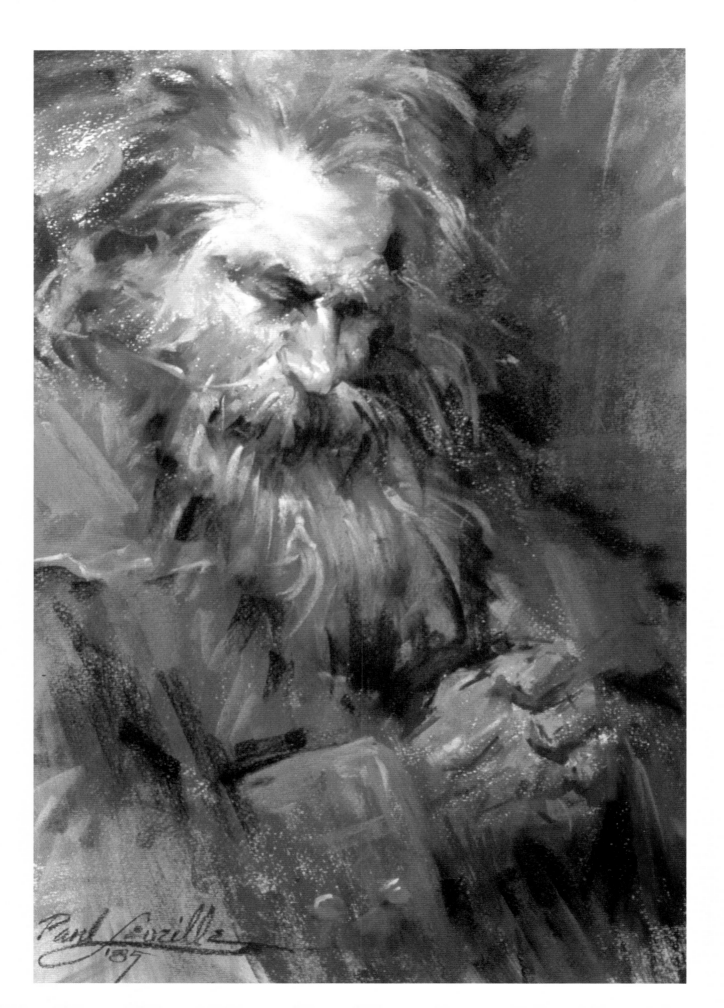

# CHAPTER

# 2 Techniques

When you begin any new endeavor, there are usually a variety of ways to make the job go more smoothly. However, when you have no guidance, you spend a lot of time "hunting and pecking" to find the best ways to achieve your goal. In this chapter, I've included some techniques I've found helpful for working in pastel. Please keep in mind that, as helpful as a new technique may be, there is no substitute for practice. It's my experience that we learn best by doing—so get those pastels out and keep on painting!

◄

**RED COAT**
*Pastel on Mohawk printing paper (cover weight), 16" × 24" (40.6cm × 61cm)*

*While reading the morning paper, I noticed a small black-and-white photograph of a homeless person. Only the eyes were visible and those eyes were the inspiration for the portrait at left. The hair, beard, coat and hands are from my imagination. I started by applying a watercolor wash for the dark areas. When the wash dried, I proceeded in pastel with the intention of creating a portrait with bold colors, strong values and crisp strokes.*

# Basic Techniques

## USING THE SHARP EDGE OF YOUR PASTEL

When you want to draw a thin mark on your painting, use the sharp edge on your pastel stick. Sharp edges form from normal use or by rubbing pastel on scrap paper. For a more defined point, try rubbing one end of a stick of hard pastel (such as Nupastel) on a sandpaper block. Turn the pastel as you rub to create a pencil-like point.

## BLENDING LARGE AREAS

When working on large areas of your painting, such as clothing or the background, first apply the overall color or colors broadly with the side of a pastel. Next, take a crumpled tissue or paper towel and lightly brush over the area. This will accomplish a variety of effects. It can blend colors, soften the look of an area by filling in the pattern of the paper and suggest motion by the way you brush over an area.

## BLENDING AN AREA WITH YOUR FINGER

There will be times when a light value meets a dark value, creating an undesirable hard edge. To soften this edge, rub your finger back and forth into both areas. The hairline on a person's forehead is often a good place to use this technique. By rubbing the forehead color up into the hair, a more natural look can be achieved. I recommend that you use this technique sparingly. Overuse in a portrait can result in dull or muddy colors and a general lackluster look to your portrait.

## USING THE SIDE OF A PASTEL STICK

To cover a large area, try using the side of your pastel stick. The amount of pressure you apply to the paper with the pastel can darken or lighten the color value.

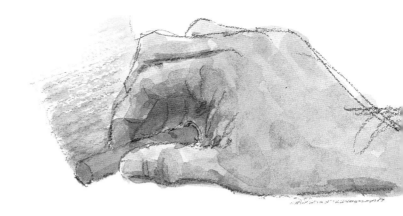

## CROSSHATCHING

To achieve a color that may not be available in one stick, try crosshatching two or three colors to come up with the one you desire. For example, if you draw a series of vertical lines with a Magenta pastel and then cross over them with a series of horizontal Ultramarine Blue lines, you will produce a purple color. Crosshatching different colors can produce vibrant, eye-catching areas in your painting.

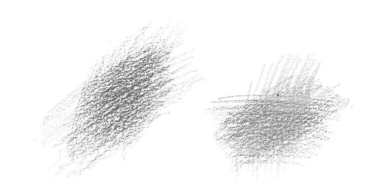

## REJUVENATING SURFACES

If you have overworked an area of your painting to the point that additional strokes of pastel will no longer adhere to the surface, have no fear. First, scrub the affected area with a bristle brush to remove all the pastel. Next, lightly spray with workable fixative. (Try to keep the spray contained to the area you are working on.)

Now, while the surface is still damp from the fixative, sprinkle pumice over the area. Spray the pumice with fixative to help it stick to the surface. When the fixative dries, you're ready to start painting again.

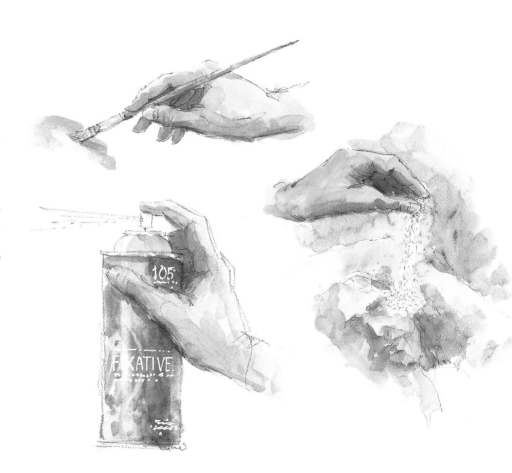

# Applying the Basic Techniques

The techniques used to create various areas of this pastel
portrait are noted below.

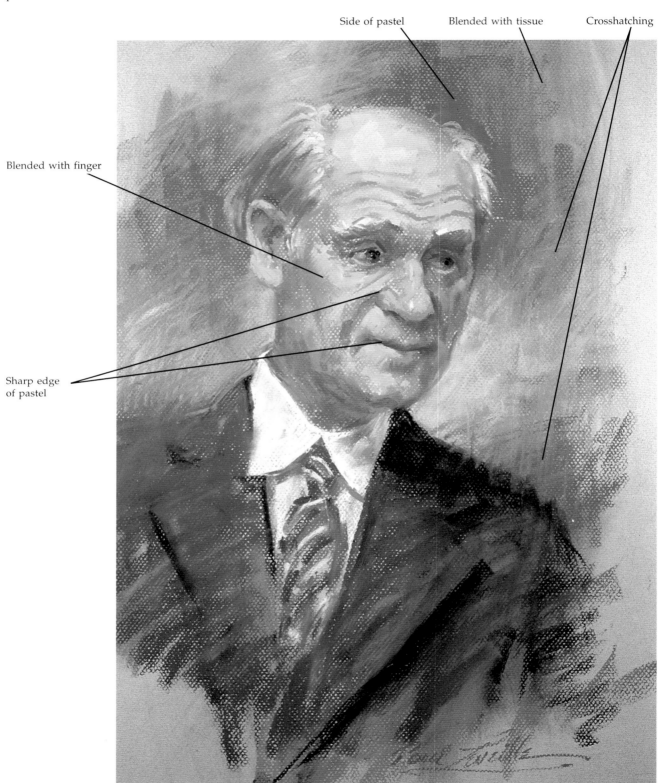

Side of pastel

Blended with tissue

Crosshatching

Blended with finger

Sharp edge
of pastel

# Pastel Surfaces

The techniques you use will vary depending on the texture of the surface you choose. These are a few of the pastel surfaces I enjoy most. I've added a broad stroke to each surface, followed by a little blending to show how their different textures work with pastel.

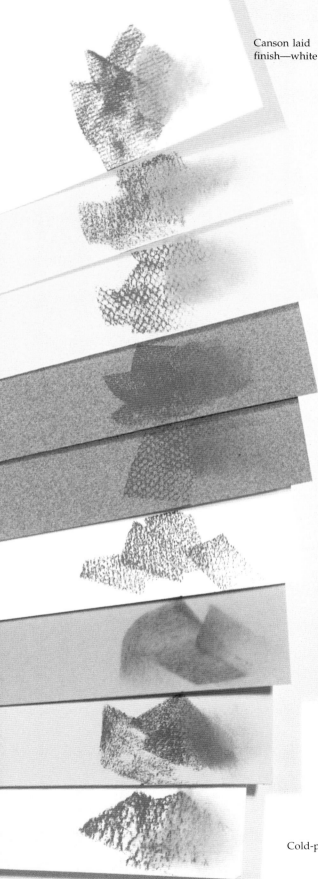

Canson laid finish—white

Canson Mi-Teintes—cream, smooth side

Canson Mi-Teintes—cream, textured side

Canson Mi-Teintes—steel gray, smooth side

Canson Mi-Teintes—steel gray, textured side

Canson heavyweight drawing paper

Velour pastel paper

Sanded pastel board

Cold-press watercolor paper

# 3 Value and Color

To achieve a three-dimensional quality in a portrait, it is necessary to paint with the correct values as well as the correct colors. Through values we can reveal the form of an object by depicting how it appears when light hits it. We can determine how light or dark an area is by using a value scale, which is usually made up of ten values from black to white. In this chapter, I've included some illustrations that may help you to find and match colors and values.

◄
**DARCY**
*Pastel on Canson Mi-Teintes moonstone (patterned side), 17" × 22" (43.2cm × 55.9cm)*

*Even though this little girl has light hair, there is plenty of contrast in the portrait due to the dark shadow areas. The dark blue-gray used in the background contrasts with the lightest areas of her hair and complements her big blue eyes.*

# Creating a Value Sketch

In this pencil demonstration you can see how I approach drawing the head through the use of values.

**1** First, I sketch the overall shape of the head and shoulders, and include the approximate position of the features.

**2** By squinting at the model, I try to determine the largest dark shapes (values). With this in mind, I sketch in the dark hat, shadows and sweater.

**3** Once I've drawn the large dark shapes, I move on to the half-tone shapes. These are the values that appear between the darkest and lightest areas. The white paper serves as my highlights.

# Adding Color

Working in black and white will help you understand the use of values to build a strong three-dimensional head. Use the same approach when working in color. Squinting at the model can help you determine the right color and value, because it tends to eliminate or lessen the brilliance of color and reduces the shape to basic areas of value by obscuring detail.

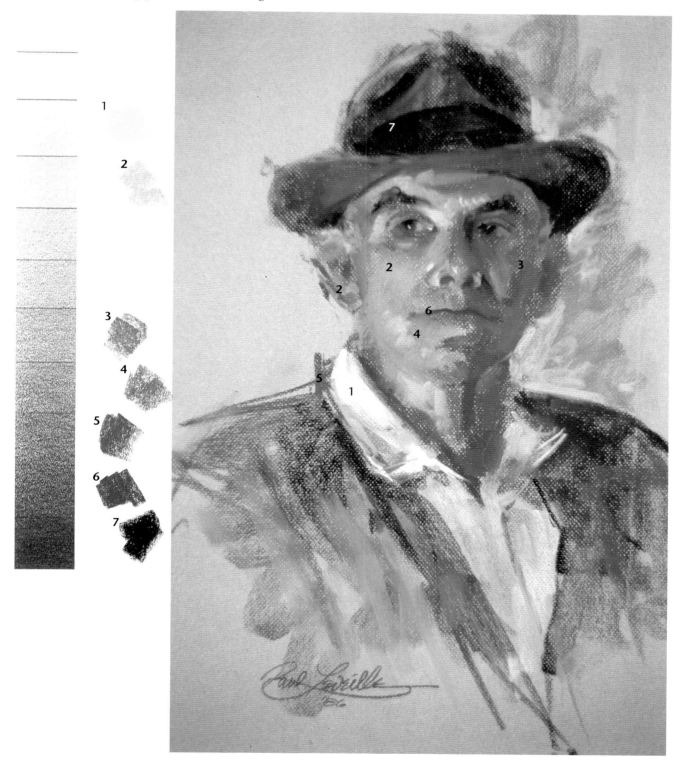

# Choosing Colors

Because of the variety of colors and values available in pastels, it is often possible to place the right mark on the portrait with one stroke. However, there are times when overlaying colors will be necessary. I've chosen a variety of complexions and hair colors for the following examples. The pastel colors I use are indicated. If you study them, you will see some direct strokes and some that overlap to get the right color or value.

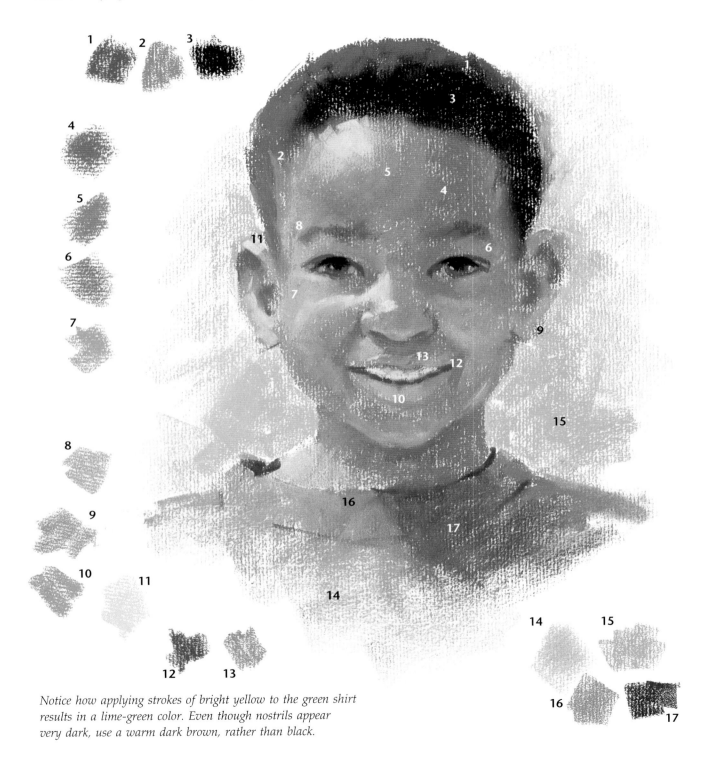

*Notice how applying strokes of bright yellow to the green shirt results in a lime-green color. Even though nostrils appear very dark, use a warm dark brown, rather than black.*

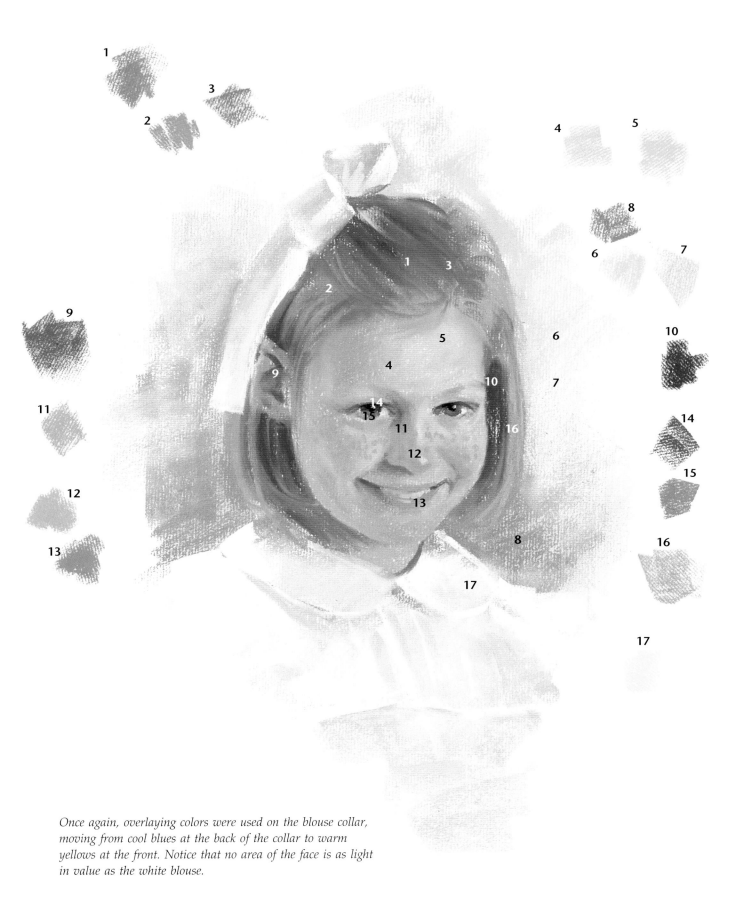

*Once again, overlaying colors were used on the blouse collar, moving from cool blues at the back of the collar to warm yellows at the front. Notice that no area of the face is as light in value as the white blouse.*

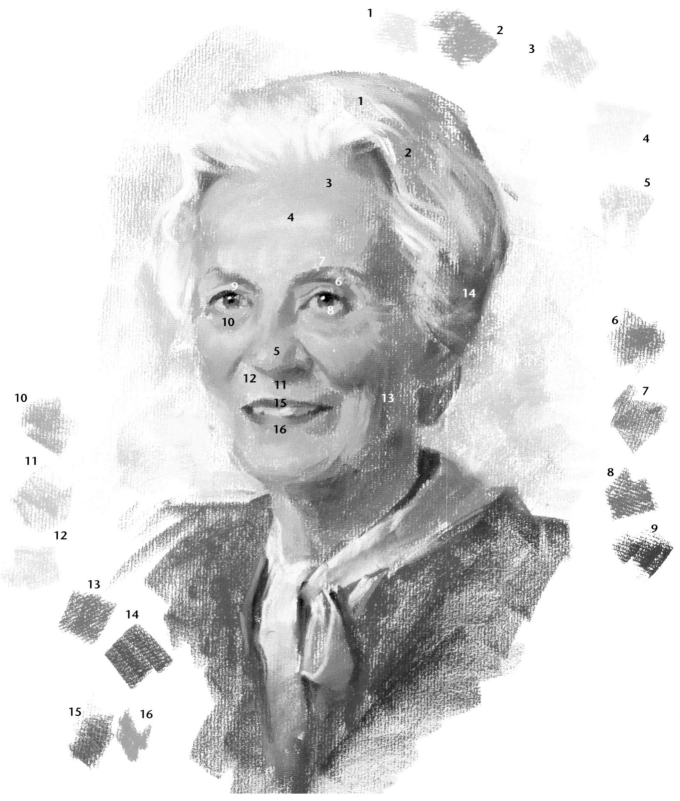

The background is predominantly cool, so I added a small area
of pink skin tone to add interest and harmony. Notice that
even though the model's hair is white, the only strokes of white
on the painting are the areas hit by direct light. Most of the
hair is in shadow and quite dark.

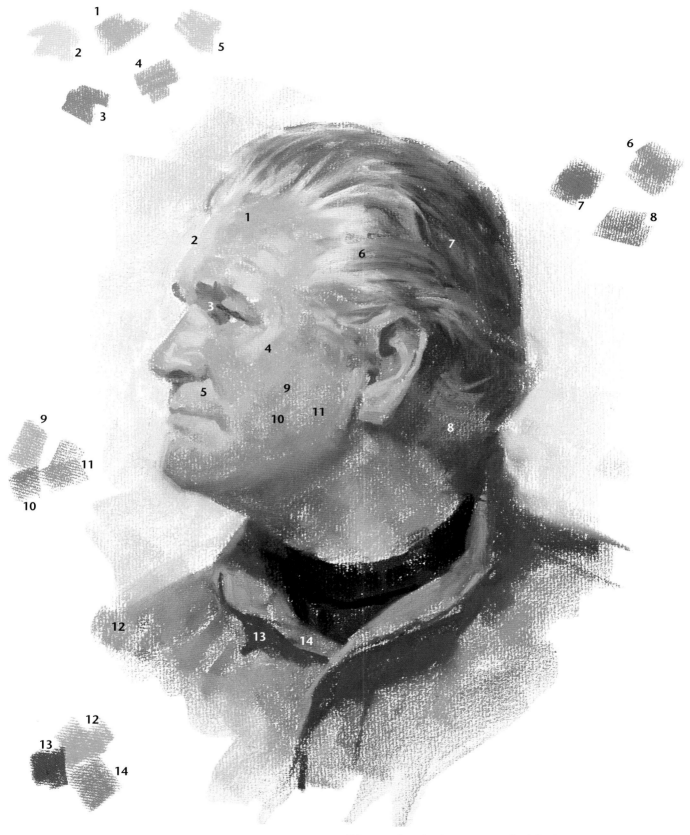

*Warm and cool colors were overlaid freely to achieve the five o'clock shadow on this model's jaw. Notice the darkest shadow area of the ear is not black, but a warm dark brown.*

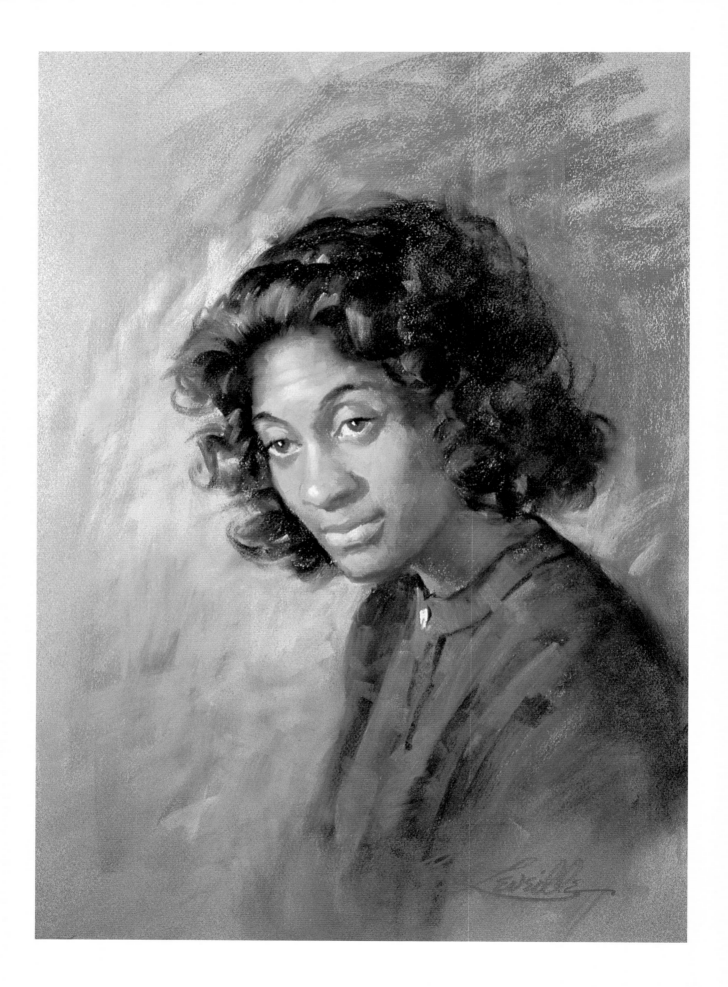

# 4 Painting the Portrait

## STEP BY STEP

When I was attending art school, I woke one morning with a sore jaw. I quickly deduced that it was a result of the dramatic pastel portrait demonstration I'd observed at school the day before. As I had watched every stroke with awe and amazement, my mouth must have hung open throughout the entire demonstration. A sore jaw was a cheap price to pay for such an enlightening presentation.

I don't expect any of you to experience jaw pain after reading this chapter; however, I believe that most artists, like myself, grasp concepts quickly when they see them demonstrated. I hope the following demonstrations will open some doors for you to painting solid portraits in pastel.

This chapter will introduce you to a variety of techniques, materials and lighting. However, I would like you to concentrate particularly on the approach used in all the following demonstrations to create the illusion of a solid three-dimensional head. First, the overall shape of the head is sketched in. The next step would be to paint the large dark and light shapes as correctly as possible in value and color, followed by the next largest shapes and so on. Developing the details of the features would come last. The following demonstrations will help explain this process in more detail.

◄

**GAYLA**
*pastel on Canson Mi-Teintes steel gray (smooth side), 17" × 22" (43.2cm × 55.9cm)*

*In this portrait, Gayla's purple sweater is the perfect color to complement her warm skin tones. Notice how I used this cool tone in the shadows of her face, the light areas of her hair and the background.*

DEMONSTRATION 1
# Young Boy With Brown Hair

## PALETTE

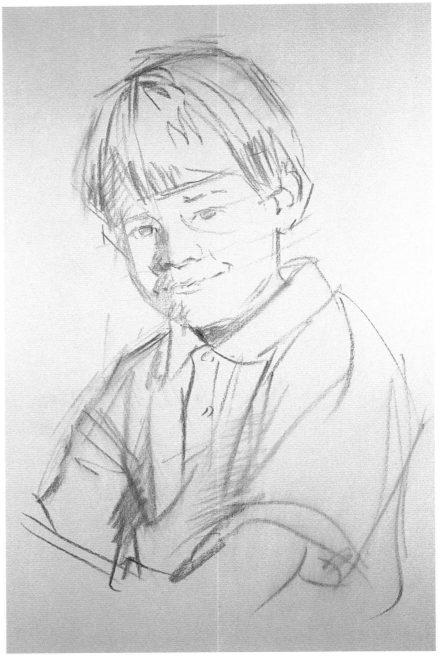

### 1 THE SKETCH

*In this portrait of a young boy, I decided to try the smooth side of a sheet of pearl Canson Mi-Teintes for a softer look. The light gray color will complement the skin tones and contrast nicely with his dark brown hair. Using a sharpened stick of medium-grade vine charcoal, sketch in the position of the head and approximate location of the features. When satisfied with your drawing, spray it with workable fixative— always spray fixative outside to prevent breathing the fumes.*

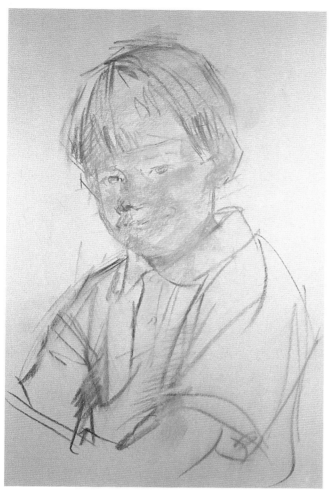

**2** **THE LIGHT FLESH TONES**
*After the fixative dries, loosely apply pink and raw sienna tones to the light side of the face.*

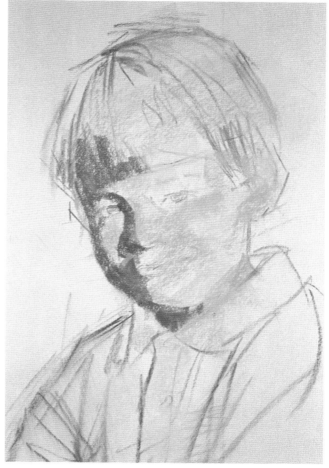

**3** **THE DARK FLESH TONES**
*By squinting at the model, you can determine the shadow values and colors. The darkest area on the side of the nose is a dark reddish purple. This color turns to a moss green on the chin and neck areas. Lay these colors in by applying medium pressure with the broad side of the pastel stick. Don't grind the color in; you may want to adjust it as you work.*

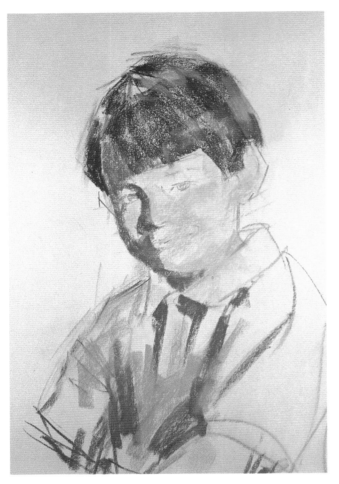
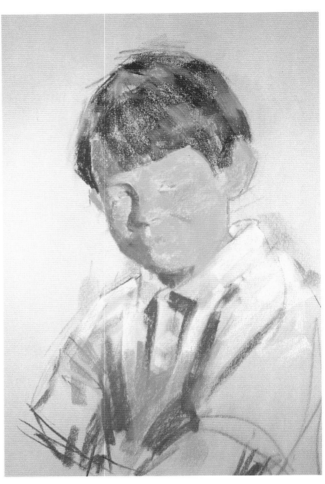

**4** **CONTINUING THE DARK VALUES**
The next dark shapes are the hair and shadows in the shirt. Use a dark brown color to establish the dark hair area. The same moss green used on the face will work well for the shirt. Add a lighter green for the lighter shirt shadows. Add a touch of this color to the lighter areas of the hair.

**5** **THE LIGHT VALUES**
Add a ruddy light red tone over the nose, cheeks and ears. Move some of this color to the hair and background for harmony. The light side of the face receives gold and sand tones. Also lighten the lower chin shadows with a light green. You'll notice I've also sketched in some strokes of cream on the collar and shoulders of the shirt. This is to remind myself where the lightest values on the shirt will fall.

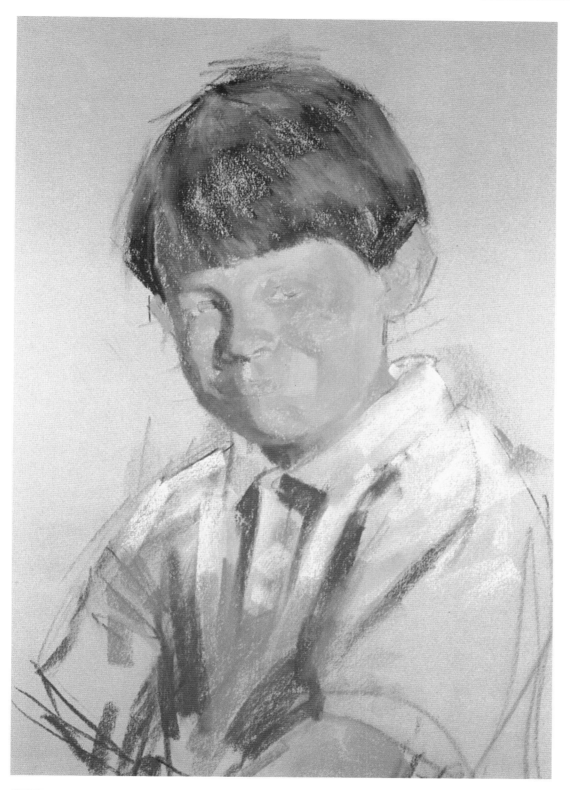

### 6 CONTINUING THE LIGHT VALUES

*Add a light putty color to the lightest areas on the light side of the face, including the forehead, the side of the nose and the side of the mouth. Apply a touch of pink to the cheek, chin and nose. Next, apply a slightly darker value of Raw Sienna to the cheeks, around the eyes, to the top of the nose and arm. Also add this color to the light areas of the hair.*

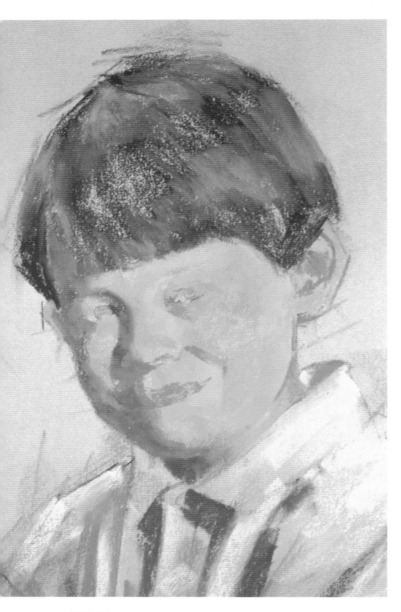

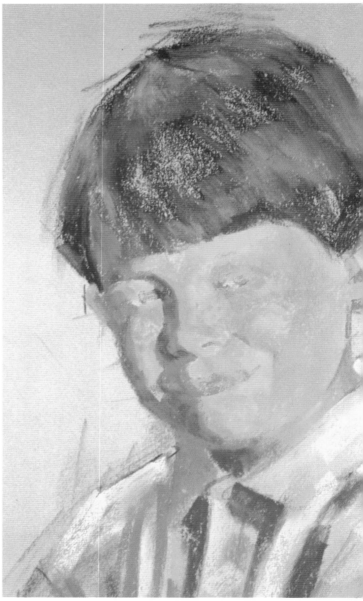

**7** **THE MIDDLE VALUES**
*To make the transition from the dark shadows to the light areas of the face more rounded, use a middle-value warm brick color for the nose and cheek in shadow. Also use this color to add the darks of the ear and to loosely suggest the shapes of the lips.*

**8** **BUILDING HIGHLIGHTS AND REFLECTED LIGHT**
*Next, add light pink to the shadow side of the mouth, upper lip area, nose and chin. Indicate reflected light on the bottom of the shadow side of the chin with a green tone. Also add this color under the lower lip. Use a warm brick color on the side of the nose and to lightly suggest freckles on the cheek and nose.*

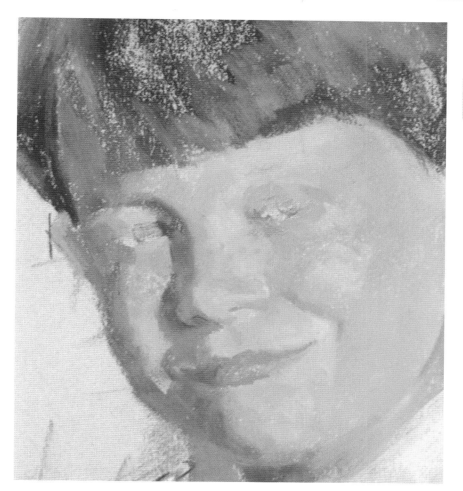

**9** **THE LIPS**
*Add a dark reddish purple tone to the shadow side of the lips.*

**10** **SEPARATING THE LIPS**
*Add a warm dark brown line between the upper and lower lips. Make the side of the line that falls in shadow a dark red-brown. Notice how the line is broken near the light side of the lips. Drawing a solid, dark line from side to side would be unnatural and distracting.*

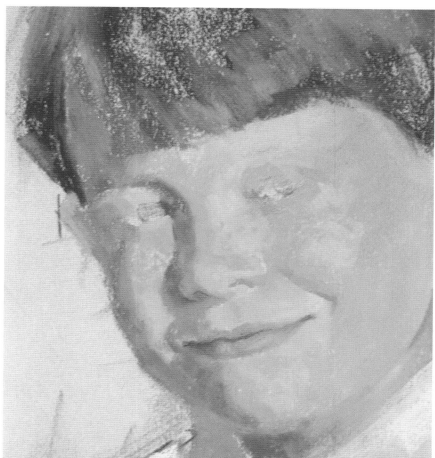

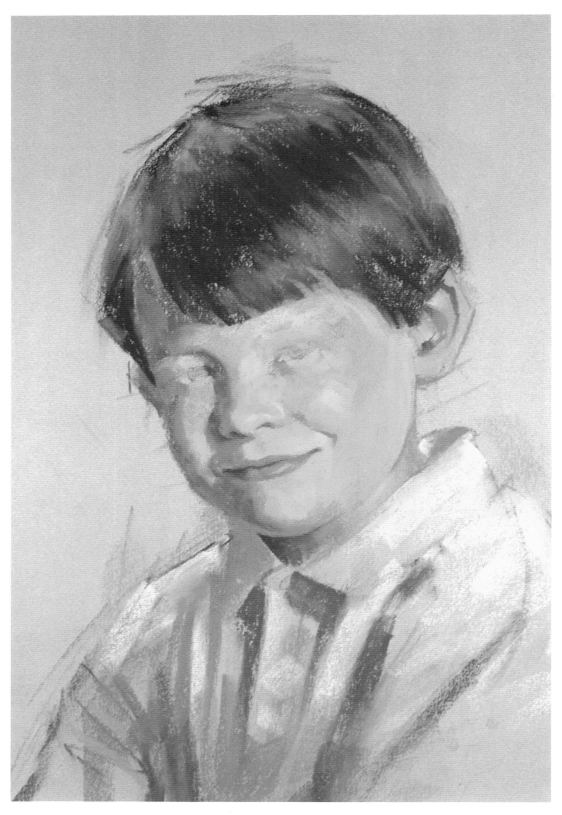

## 11 BUILDING THE LIGHTS AND DARKS FURTHER

*Put in the nostril with a warm red-brown pastel. Apply a light peach color to the nose, forehead and cheek. Add more dark brown to the hair.*

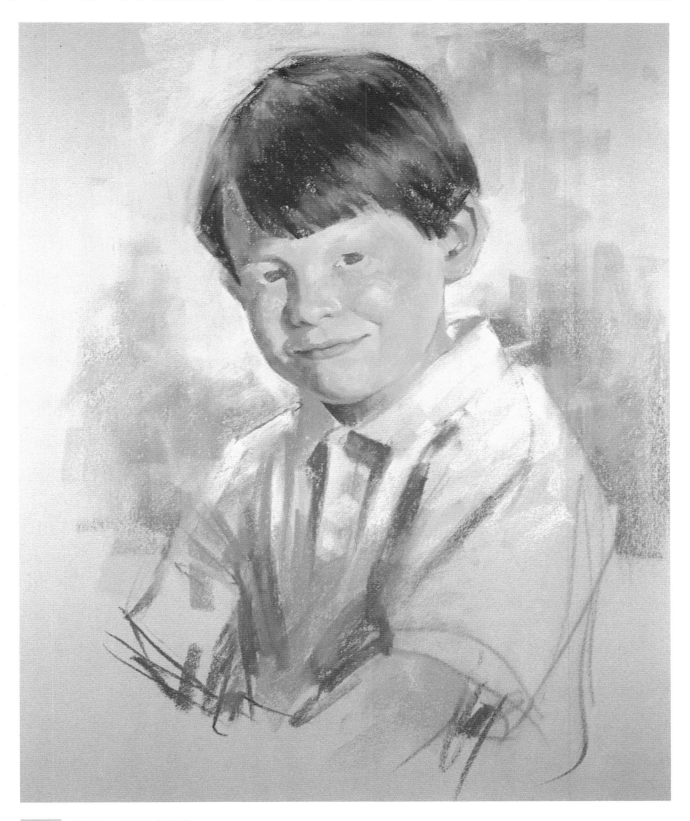

## 12 THE BACKGROUND

*Using the broad side of the pastel sticks, add blues, greens and warm golds to the background. The warm colors repeat the skin tones, adding color harmony to the portrait. While you are using greens, position the irises with an olive green.*

**13** **THE EYES**
*Go over the inside of the iris with a light pea green color. Use a darker olive for the outer portion. Add black for the pupil and upper lashes.*

**14** **THE EYEBROWS**
*Eyebrows are usually made up of light and dark colors— not one solid color. For these eyebrows, start by adding a greenish umber color to the inside of the eyebrow on the shadow side of the head. On the light side, use umber and a warm brown for the light areas. The beginning of this eyebrow can be softened by rubbing the area with your finger.*

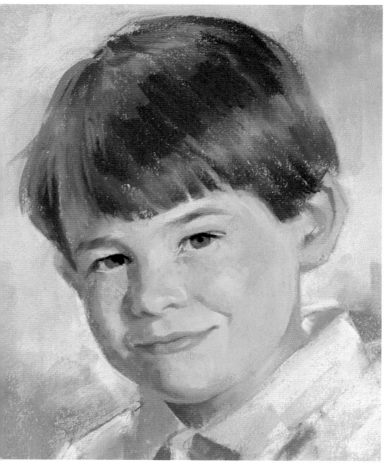

**15** **THE EYEBROW AND HAIR DARKS**
*Now add the darks to the center of the eyebrow with a deep warm brown. Add the darkest brown to the hair.*

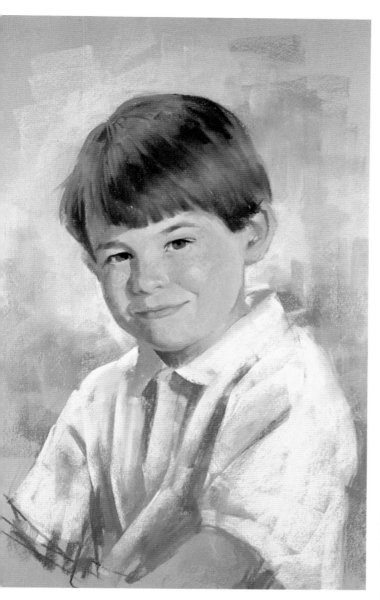

**16** **THE HAIR AND SHIRT LIGHT VALUES**
*The light areas of the hair receive gold tones made with direct strokes. Remember to wipe your pastel after each stroke to clean off any dark color that you have picked up from the painting. Fill in the light areas of the shirt with a cream color.*

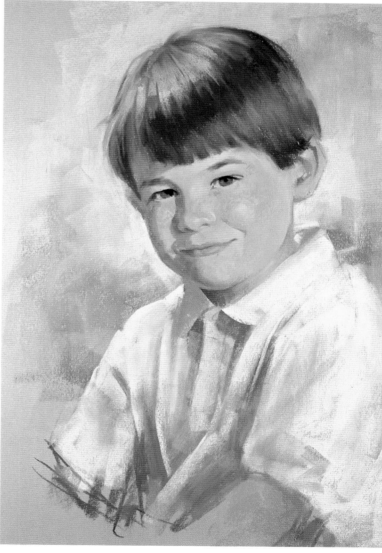

**17** **ADDING REFLECTED COLORS**
*Using the broad side of the pastel stick, add light blue highlights to the hair with bold, crisp strokes. Lightly apply pinks and blues to the shirt.*

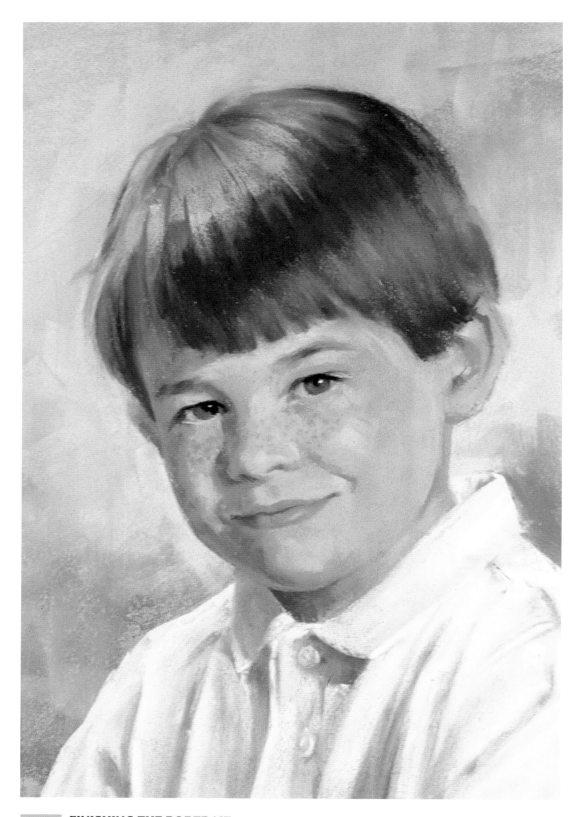

**18** **FINISHING THE PORTRAIT**
*Add highlights to the eyes, using a light cream for the eye on the light side of the head and a darker value tan for the highlight on the shadow side. Add bright whites to the lightest areas of the shirt, and soften the shadows. Refine the freckles with a warm brick color.*

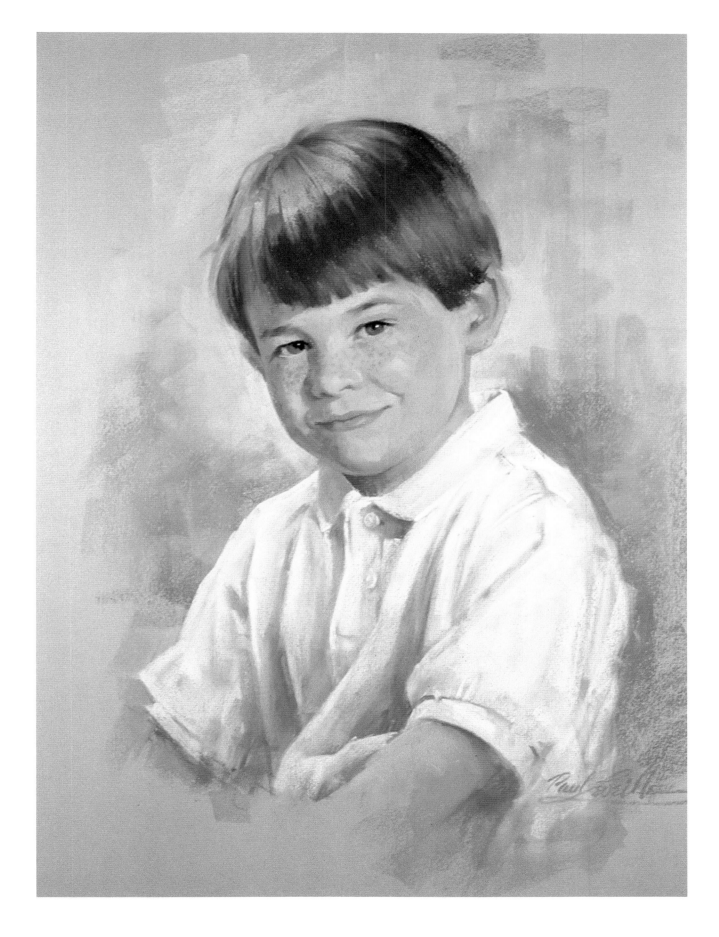

## DEMONSTRATION 2
# Older Woman - Outdoors

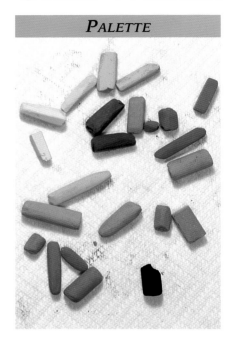

**PALETTE**

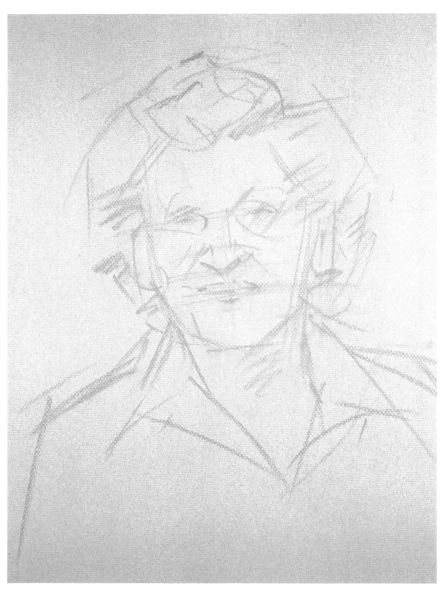

**1** **THE SKETCH**

*Start this portrait by sketching directly on a piece of Canson Mi-Teintes moon-stone (no. 426) with a middle-value lavender color. Allow about three inches between the top of the head and the top of the paper. The size of this head could be about seven and one-half inches top-to-chin. Stay loose and sketchy, without committing your-self to details. Simply try to define the overall shape of the head and approximate position of the features.*

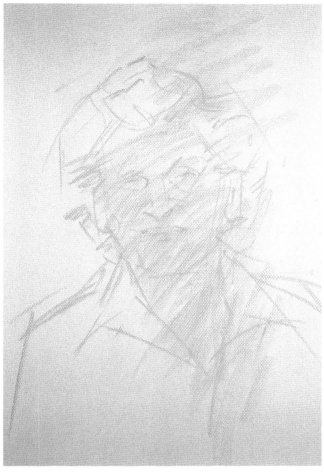

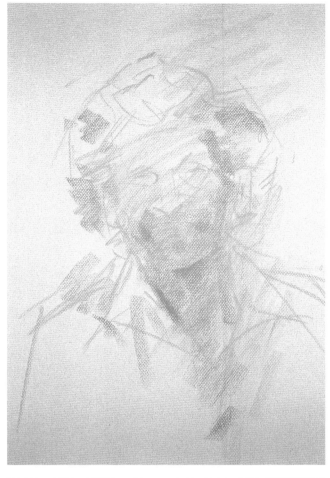

**2** **THE BASIC FLESH TONE**
*Scumble a flesh tone over the drawing. Keep a light touch—you don't want to grind color into the paper.*

**3** **THE LOWER PORTION OF THE FACE**
*In this case, the lower portion of the face is receiving less light and is a bit darker in value. Apply a raw sienna tone over this area.*

**4** **THE LIGHT TONES**
*Next, add a blush color over the cheeks and nose. Continue to use a light touch in your application at this point. Also add a light yellow ochre tone to the forehead and chest.*

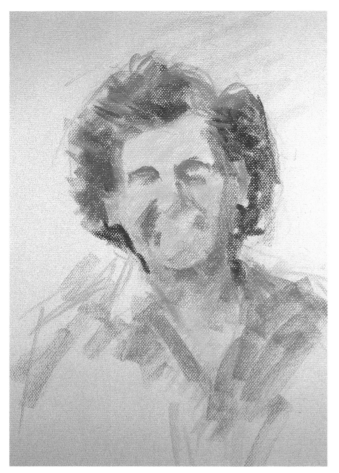

**5** **THE DARKS**
Now it's time to go for the darks, which include the shadows and hair. Use a greenish umber for the shadow area on the side of the cheek and an Indian red color for the eye sockets. The hair receives a dark brown tone on the shadow side. On the light side use a light brown, followed by golds and light greens. Add some green to the blouse.

**6** **THE HALFTONES**
Now that you have the large dark and light shapes blocked in, it's time to start working on the halftones. Let's start with the mouth, chin and nose area. Keep in mind the lighter halftone areas will appear to come forward, while the darker areas tend to recede. Use more greens and golds for the mid-tone areas. The darker halftones are more burnt orange in color. Add some umber tones near the folds of the cheeks.

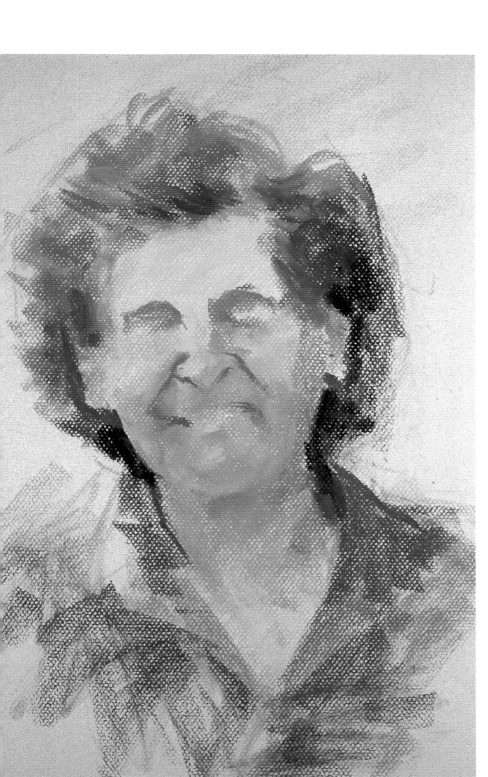

### 7 MORE DARKS

*Add some warm orange tones to the cheeks and nose, as well as the top of the chin. Apply a darker red-brown color to the folds in the cheeks. Use this color to indicate the ends of the lips and the nostrils. The rich dark of the hair at the back of the neck is achieved with a black pastel. The blouse receives a dark blue-green tone.*

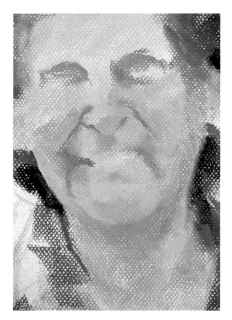

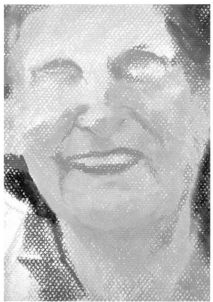

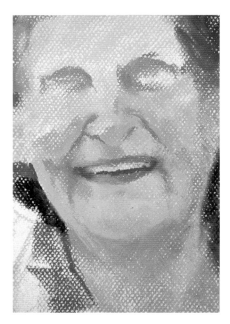

**8** **DEFINING THE FACE**
Continue to define the cheeks and jaw by adding more halftones. Add a darker warm tone under the chin to make it appear to come forward. Keep in mind that this is an outdoor portrait: The skin tones contain a lot of greens reflected from the foliage. Add some light greens to the light area above the mouth and chin.

**9** **THE LIPS**
Put in the basic shapes of the upper and lower lips with a burgundy color.

**10** **REFINING THE LIPS**
Add a slightly lighter and brighter tone of red on the lips where they are receiving more sunlight. Put in the dark area between the lower lip and teeth using a dark red-brown.

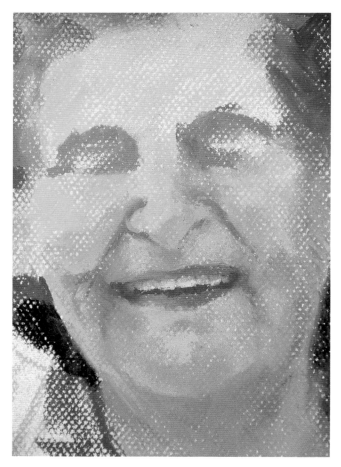

**11** **THE TEETH AND NOSE**
Add a few light areas to the teeth to help shape and define them a little. Also include a few warm halftones above the teeth to suggest spaces between teeth. Try not to overdo this. Apply some warm pinks to the areas of the cheeks and nose in the light. Add some warm mid-tones around the nostril areas. Warm darks can be added to the eye socket areas.

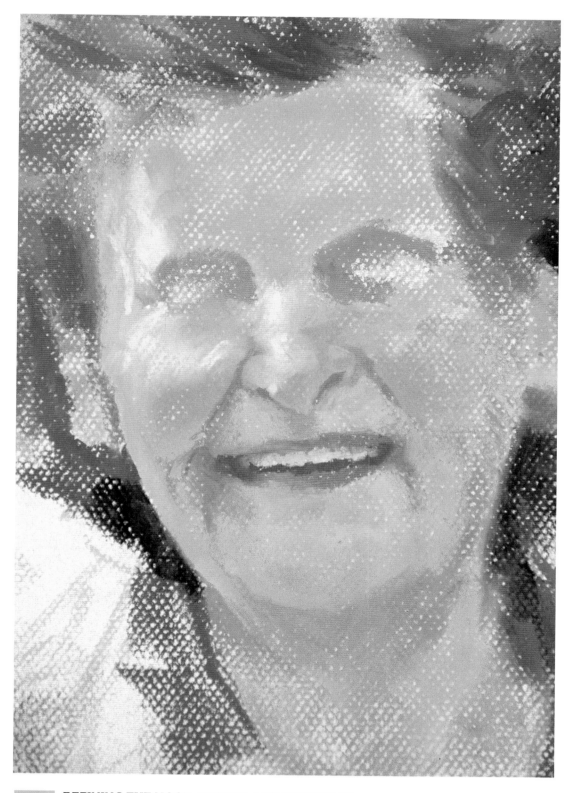

### 12 REFINING THE NOSE, CHEEKS AND FOREHEAD

*Start working towards the highlights by adding light pinks to the nose, followed by a very light cream color for the highlights on the bridge and tip of the nose. Repeat the process for the cheek. The nostrils are made up of a dark reddish brown color. The forehead receives a light golden color.*

### 13 THE EARS AND EYES

*Add a warm gold tone to the lower portion of the ears, then add warm darks. A warm light olive color can be applied to the brow areas to indicate the turning of the form from dark to light. Add warm lavender tones under the eyes.*

### 14 THE SOCKET AREAS

*Redefine the darks in the socket areas with a dark reddish purple. Now is the time to add more pressure to your pastel stick to get richer darks.*

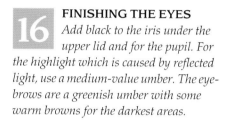

### 15 THE EYES AND FOREHEAD

*Using a rich dark brown, put darker areas in the sockets and include the irises. Add a touch of reddish purple under the eyes. Apply a little light green to the light areas under the eyes. A warm, medium-tone color should be added to the forehead to indicate shadows from the hair.*

### 16 FINISHING THE EYES

*Add black to the iris under the upper lid and for the pupil. For the highlight which is caused by reflected light, use a medium-value umber. The eyebrows are a greenish umber with some warm browns for the darkest areas.*

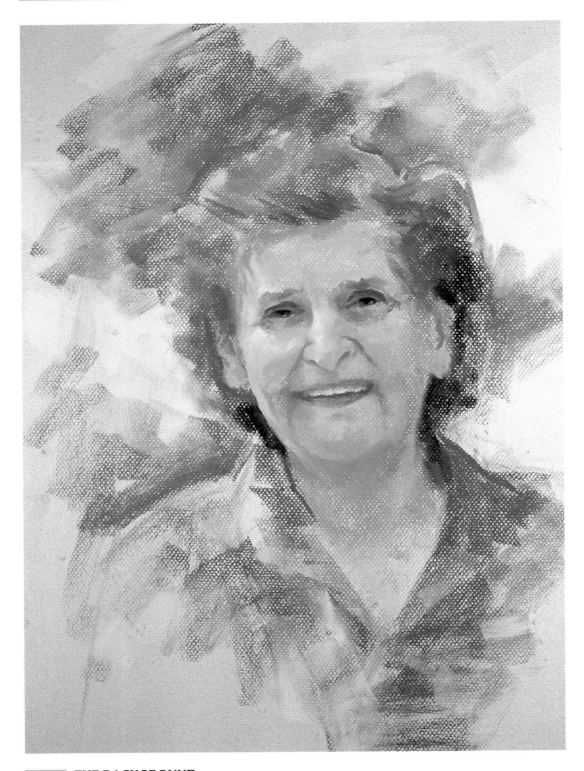

**17**   **THE BACKGROUND**
*Move a forest green color into parts of the background. Also include some areas of light blue to suggest sky. Move these colors into the blouse. Stay loose with your application. Move some of the background color into the hair to avoid an outlined look.*

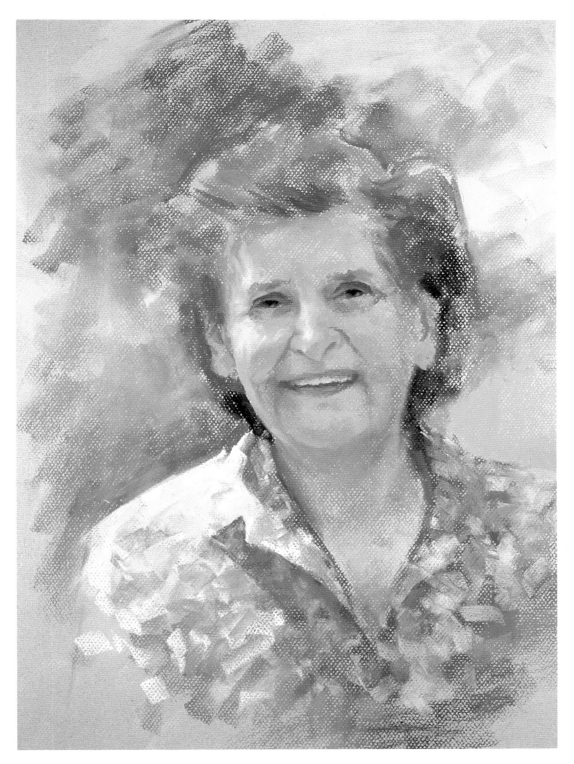

**18**  **THE BLOUSE**
*Add a dark blue-gray on the shadow side of the blouse. Add some lavender and cream notes over the blue-gray. On the light side, keep the lavenders more pink and the lightest areas almost white. A light yellow brightens the background.*

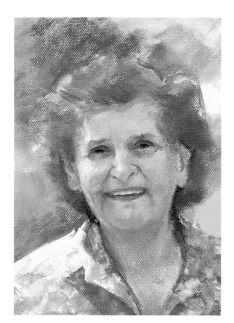

**19** **THE HAIR**
*Soften the dark areas by lightly rubbing with a paper towel. This will fill in the waffle pattern of the paper and make it less distracting.*

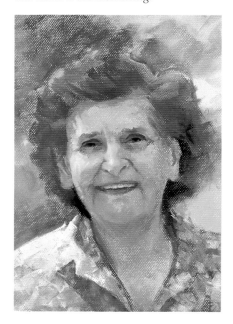

**20** **REDEFINING THE DARKS**
*Now redefine the darks in the hair using black and then dark brown. Also add some dark olive tones.*

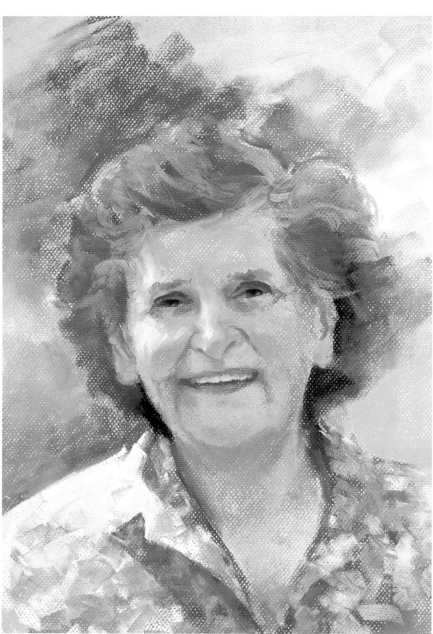

**21** **THE LIGHTER HALFTONES**
*Add the lighter halftones to the hair using pea greens and warm browns.*

**22** **COMPLETING THE PORTRAIT** ▶
*Continue to add light tones to the hair. Richer color is added to the background. Darks made up of red-purples are added to the hair, along with the final highlights.*

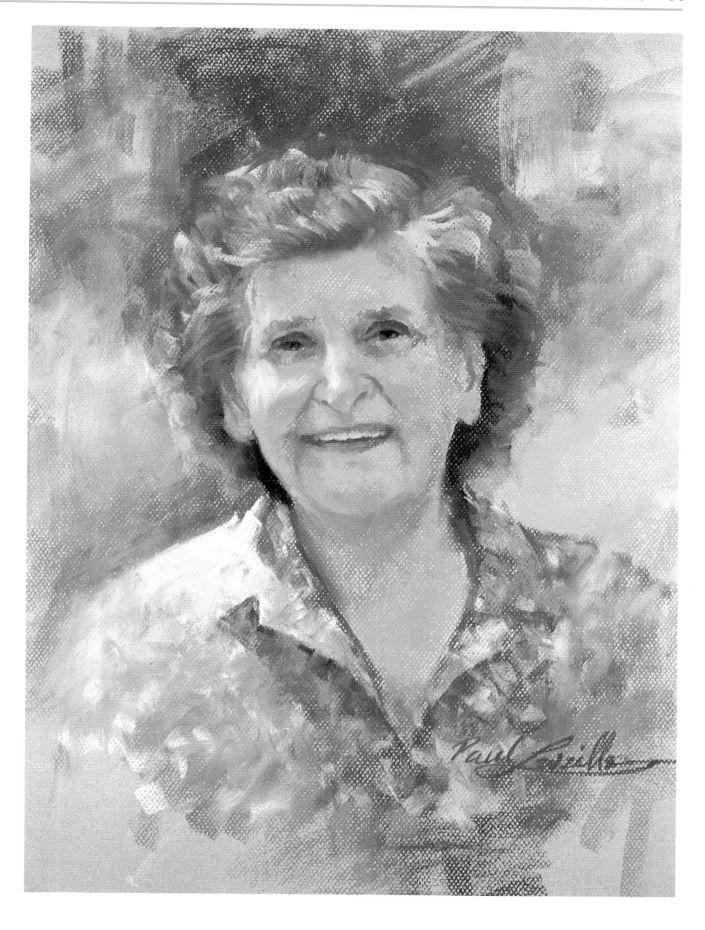

## DEMONSTRATION 3
# Teenage Boy With Blonde Hair

### PALETTE

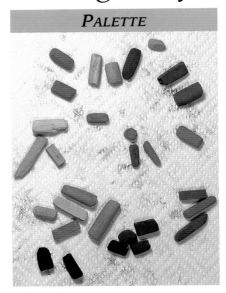

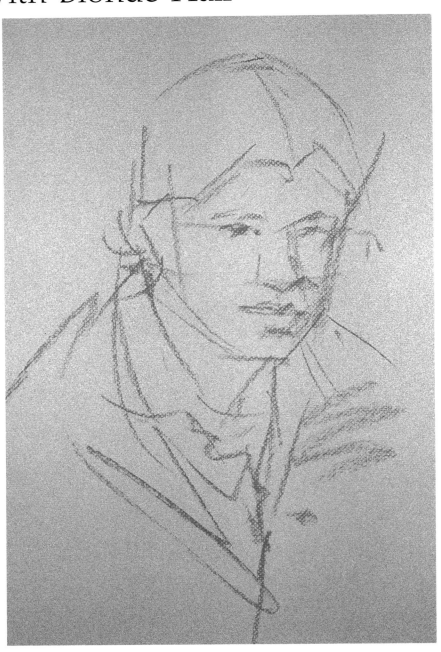

### TRY A NEW SURFACE

Canson Mi-Teintes is available as sheets of paper and in board form. The board is equal in weight to mat board and is ideal for developing larger paintings. The board's surface is the textured side of the Mi-Teintes paper. Because the board is stiffer than paper, there is a slightly different feel—it gives less when applying pastel. However, it is still a softer surface than one sheet of paper clipped to a piece of Masonite. The board also takes gouache or watercolor very well as a base for a pastel painting.

**1** **THE SKETCH**
*For this demonstration we'll be using a piece of steel gray Canson Mi-Teintes board. Jumping right in, sketch the head with a piece of Raw Umber pastel.*

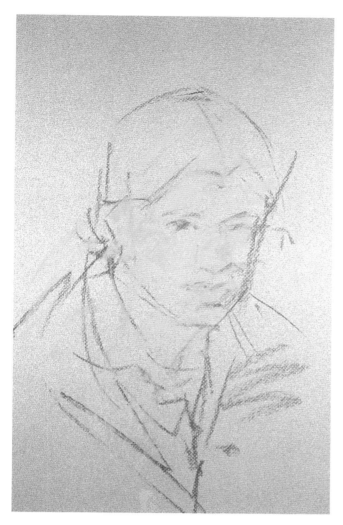

**2** **THE BASIC FLESH TONES**
*As a base tone for the light side of the face, lightly apply a clay color. Give the cheeks, nose and ear a salmon color. Add a little of this color to the shirt and hair for harmony.*

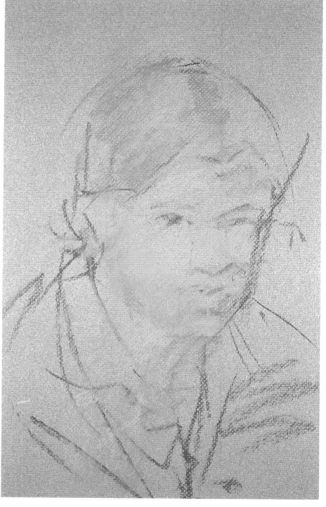

**3** **THE DARKER FLESH TONES**
*The lower portion of the face is receiving less light, so use colors a little darker in value. Apply light olive, followed by raw sienna tones, extending into the hair and neck.*

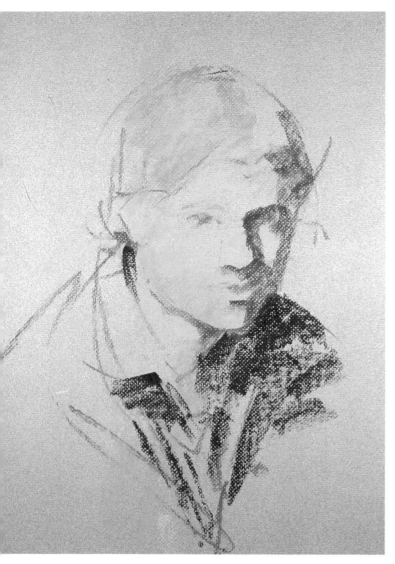

**4** **THE DARK SHAPES**
*The large dark shapes are next. Block in the shadow shapes on the face with a deep maroon color. Apply a deep Ultramarine Blue color for the shirt shadows.*

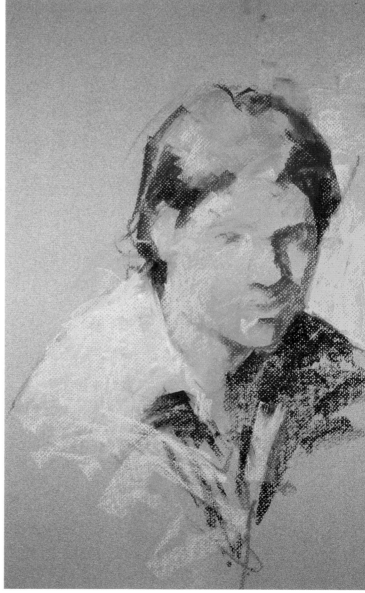

**5** **MORE DARK SHAPES**
*Define the dark areas of the hair with a red-brown, followed by a darker brown. Next, apply a cool, light green to the light side of the shirt. Add a few touches of this color to the face. Paint a contrasting light yellow-orange color in the background on the shadow side of the head. Lightly add some of this color to the shirt and hair.*

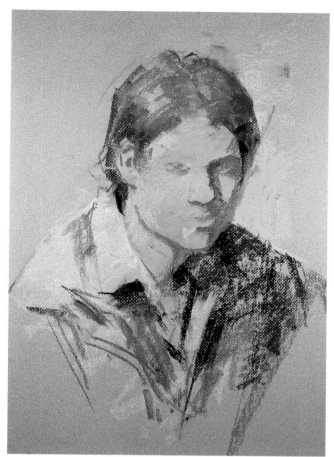

### 6 THE SHADOW AREAS
*Add a deep olive tone to the areas of shadow on the face, hair and shirt. Lighten some of the shadow area of the face with a cool red-brown. Add a rust color to the hair and shadow areas. Add black for the deep shadows of the shirt and hair.*

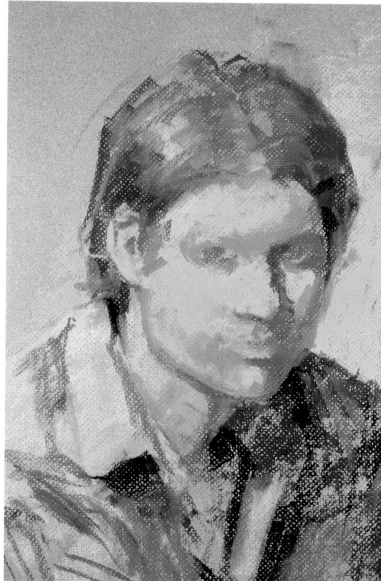

### 7 THE LIGHTER TONES
*Add a peach tone to the face and a few touches to the shirt and background. Add olive tones to the lower portion of the face, including the jaw line and around the eyes and sideburns. Add a raw sienna color to the forehead, cheek and around the mouth. Use a cool blue-gray to suggest the position of the irises. Add touches of this color to the shirt.*

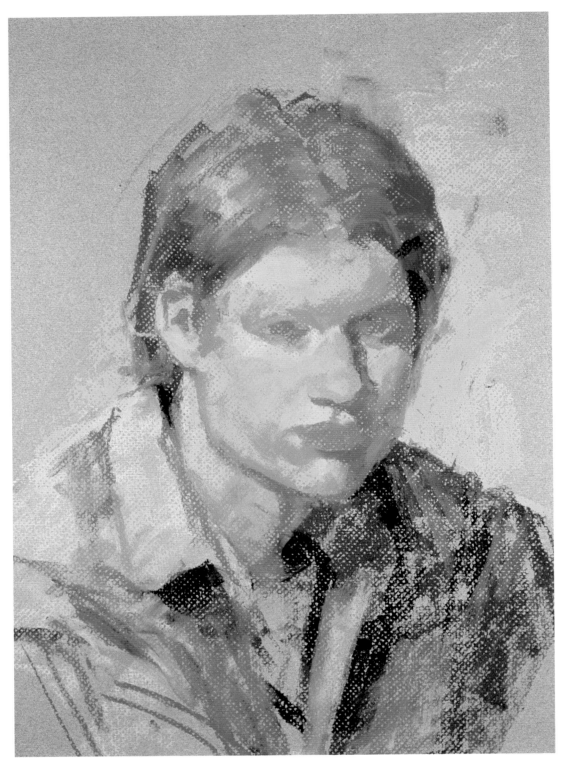

**8**   **MORE LIGHT TONES**

*Add a light gold color to the areas under the nose, on the chin, the forehead and under the eye. Go over these areas lightly with a cool, light green. Add a brick color to the nose and cheeks, and a few touches to the shirt. Suggest the lips with a deep rust color. Because this color is so eye-catching, it's a good idea to find other areas in the painting in which to use it so it doesn't become a focal point: The ears, corners of the eyes and parts of the hair will work nicely.*

### 9 THE LIPS

Add a dark red-brown for the upper and lower lips in shadow. Also use this color to draw the line between the lips. Apply a dark rust to the bottom of the lower lip to indicate a curve in the form from light to dark.

### 10 THE LIPS AND NOSE

Add a pink highlight to the lower lip. Redefine the nose shadow with a deep red-purple. Apply the nostril on the light side with a red-brown tone. Use a deep red-purple to define the darkest area within the nostril.

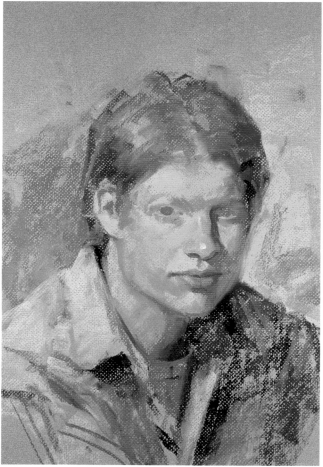

**11** **THE NOSE AND EYES**
*Add a light pink highlight to the tip and bridge of the nose. Use a sand color on the upper part of the nose bridge and under the eye. Fill in the whites of the eyes with a putty color for the light side; a raw umber tone for the shadow side. Redefine the irises with a cool blue-gray.*

**12** **THE EYE AREA AND BACKGROUND**
*Apply the shelf of the lower eyelid with a light pink tone. Use a rust color over the eyes. Give the background a few strokes of the same cool blue-gray used for the eyes. Add some light skin tones to the hair.*

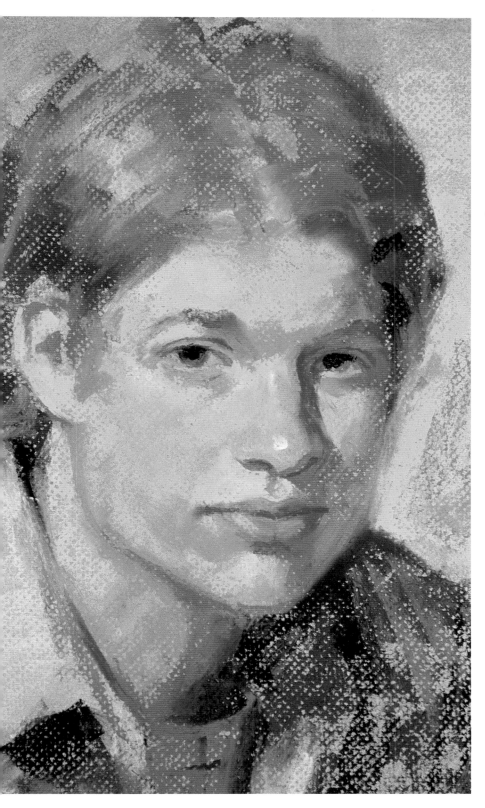

### 13 THE EYES AND EYEBROWS

*Use a brick red for the lid over the eye on the light side. Use a darker red-brown for the lid on the shadow side. Add the pupils with Ivory Black. Start the eyebrows using a brown tone. Soften the beginning of the brows by lightly rubbing with a finger for a more natural look.*

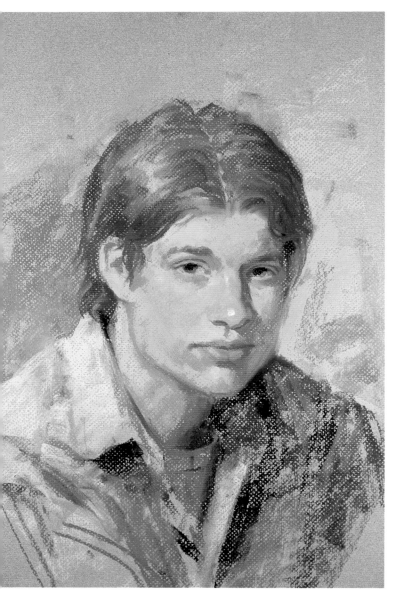

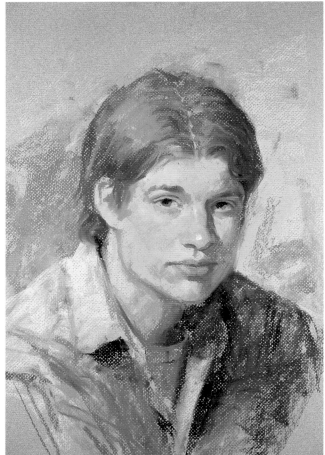

**15** **THE LIGHTER AREAS OF HAIR**
*Add a burnt sienna tone to the lighter areas of the hair. Add touches of this color to the light parts of the shirt.*

**14** **THE EYEBROWS AND HAIR**
*Complete the eyebrows using a dark green tone on the shadow side and a touch of dark brown for the eyebrow on the light side. Darken the upper lids with a red-brown. Apply a warm dark brown to indicate the shadow between the hair and forehead. Apply a deep dark brown to the hair, followed by a golden brown tone.*

**16** **COMPLETING THE PORTRAIT** ▶
*Add the hair highlights with a yellow ochre tone. Add a brighter light green to the shirt, as well as a few touches to the highlight areas of the hair. Add more golds and light blue-greens to the background. Use a cream color for the highlight in the eye on the light side. Use a slightly darker value—an umber color—for the eye on the shadow side. Add a few bright pink strokes to the forehead and cheek areas.*

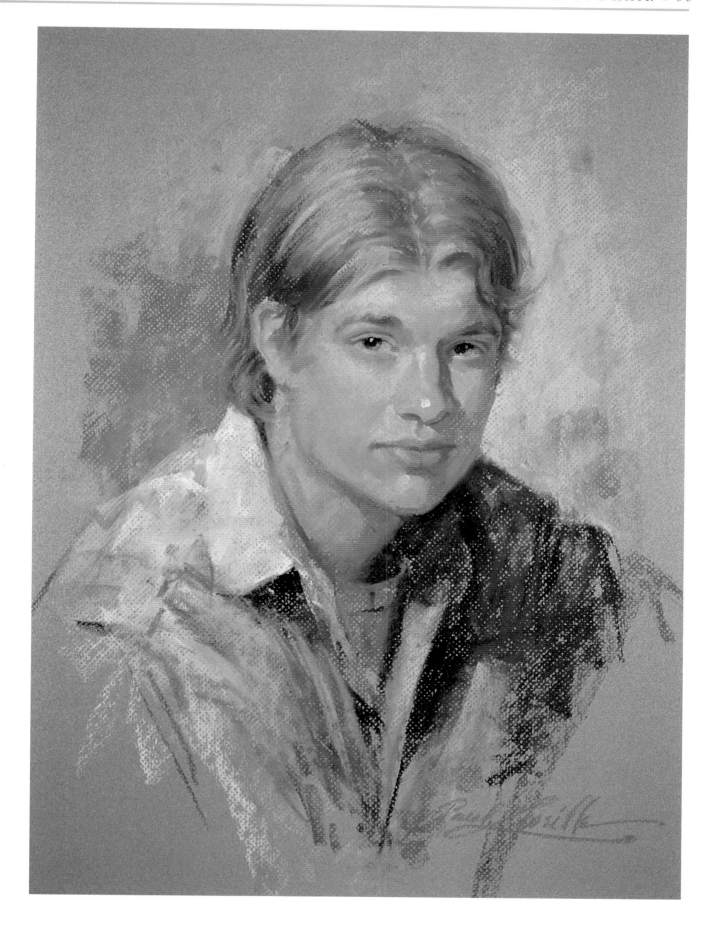

*DEMONSTRATION 4*
# Fisherman

PALETTE

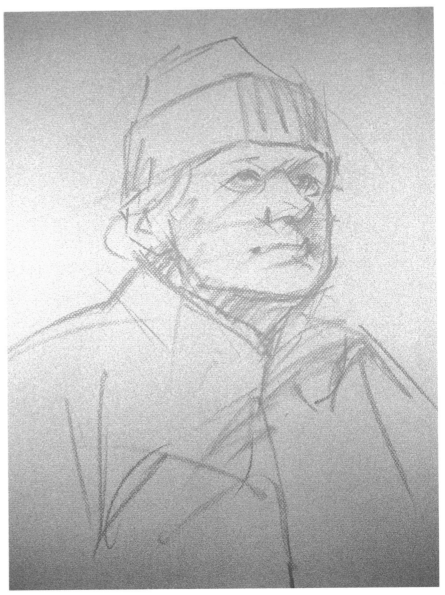

## 1   THE SKETCH

*Start this portrait by sketching directly with pastel on Canson Mi-Teintes steel gray (no. 431). Select a pastel color that closely matches the general color found in the shadows—in this case a raw umber color would be good. Sketch the head and features loosely. This is not the time to get involved with details. You may want to make changes as you go along, so try not to commit yourself too soon.*

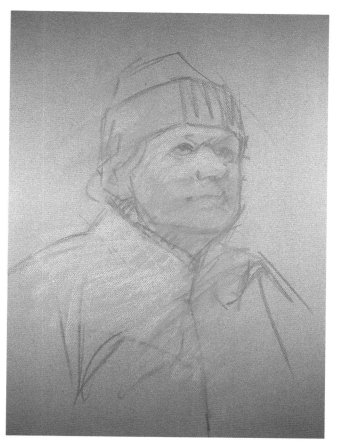

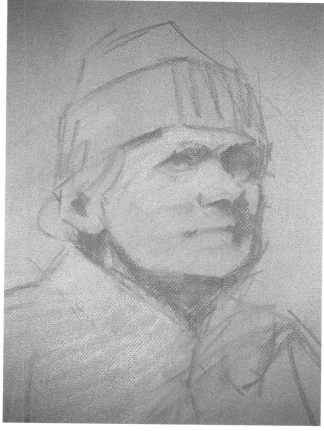

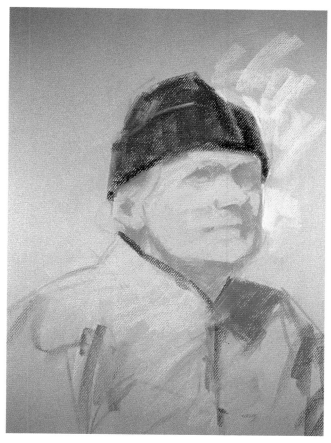

**2** **THE BASIC SKIN TONES**
*Once you're comfortable with your drawing, select a light color that closely matches the overall skin tone on the light side of the face. Using the flat side of the pastel, apply it lightly over the drawing. Using the same method, add a slightly darker skin tone to the lower portion of the face. Also add some ruddiness to the nose and cheeks. Add some yellow to the slicker and bring some into the background. Move these colors around, staying loose and free. Don't be afraid to go outside the lines.*

**3** **THE LARGE SHADOW AREAS**
*Put in the large shadow areas using an Indian red color. Keep your strokes broad and loose, but try to duplicate the shapes of these shadows as closely as possible. At this time, don't worry about the variations in color and value that occur in the shadows. Keep it simple.*

**4** **MORE DARK SHAPES**
*Continue blocking in the dark shapes, including the navy cap and olive shadows on the slicker. Add some light blue to the background. Some of this blue can also be added to the slicker.*

### 5 THE LOWER PORTION OF THE FACE

*To shape the chin, add values between the dark shadows and light areas, such as the warm halftones along the jaw and chin. Then add some of the light greenish tones above the upper lip.*

### 6 THE CHIN, LIPS AND SHADOW AREAS

*Add pinks to the chin and around the lips. Now is a good time to adjust some color in the shadow areas. The shadow areas under the nose and side of the mouth are more of a green tone. Try to keep the same dark value for these areas.*

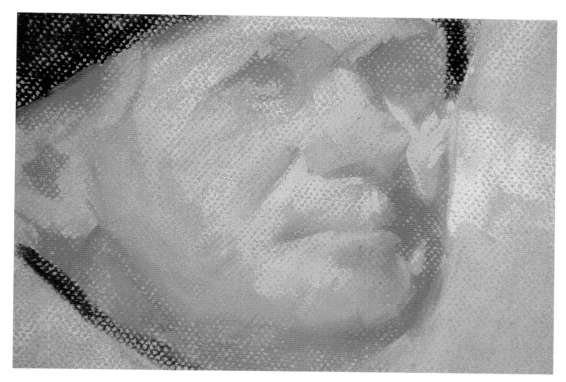

### 7 THE NOSE

*Moving up to the nose, add some warm, reddish halftones. Define the shadow area more.*

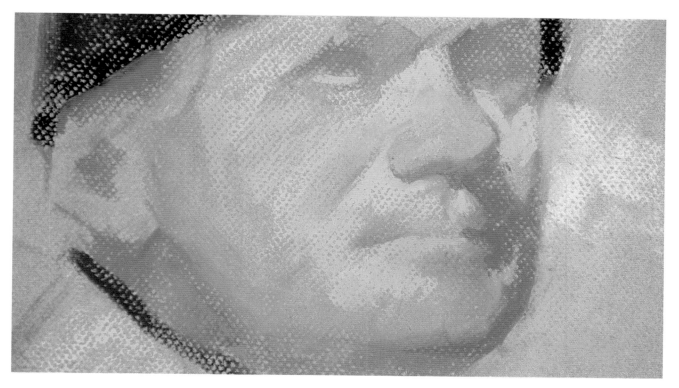

### 8 REFINING THE NOSE

*Add the light halftone areas on and around the nose. Start to refine the warm dark areas on the side and under the nose.*

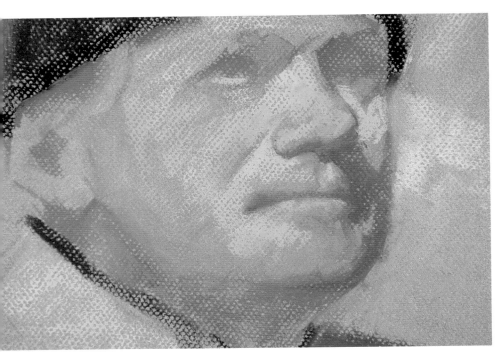

**9** **THE MOUTH**
*To build the mouth area, start by adding the next to darkest area on the upper lip using a red-brown.*

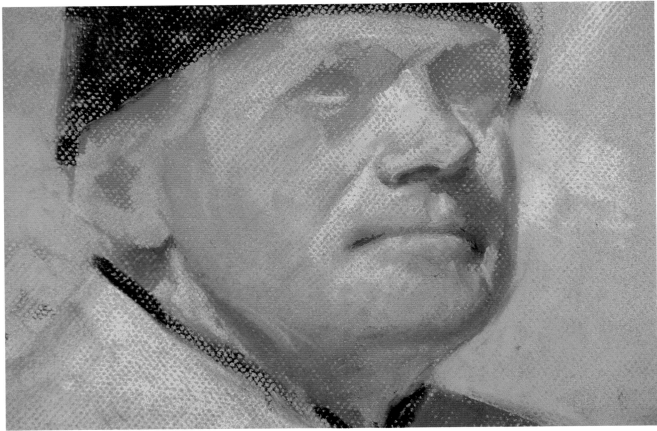

**10** **DARKER VALUES AND REFLECTED LIGHT**
*Next, add the darkest areas of deep reddish brown between the lips and at the ends of the mouth. This color can also be used for the nostrils. Strengthen the shadows under the chin. The darker values will push the chin forward. Using a light orange-brown color, add the reflective light area under the jaw. Be careful not to go too light.*

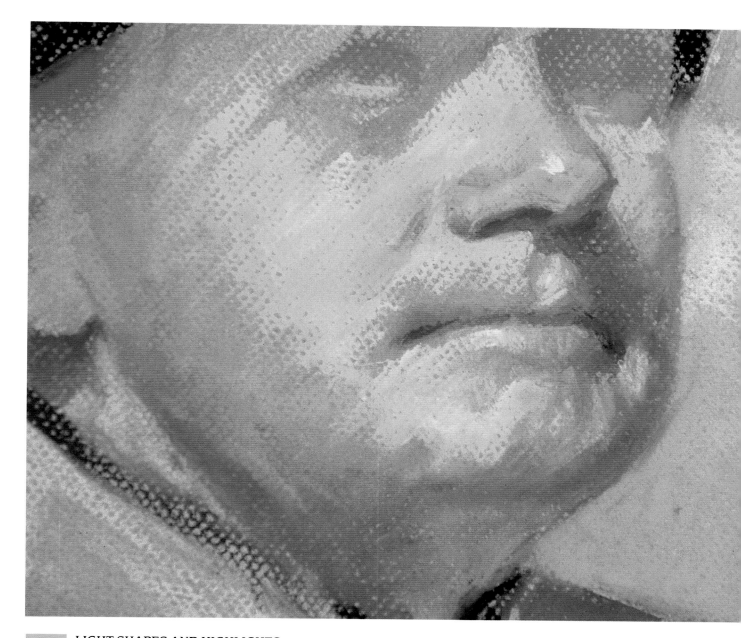

## 11 LIGHT SHAPES AND HIGHLIGHTS

*Now that you have completed the darks and middle halftones, it's time to add the light shapes and highlights. Apply a very light, golden tone to the chin and above the upper lip. Add a bright pink highlight to the lower lip. The tip of the nose receives a bright, cool pink highlight. Finally, redefine the dark red-brown between the lips.*

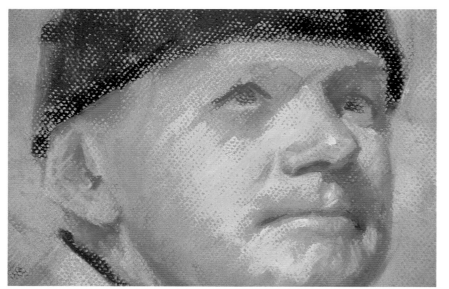

### 12 THE EYES AND EAR

*Start by loosely indicating where the irises should be positioned using a blue-gray pastel. Reestablish dark shadow areas with dark Indian red colors. Notice as the dark shadow forms turn toward the outside, they receive reflective light and turn lighter and greener. Also add the dark red-browns of the upper lids. Add an overall warm middle tone to the ear, then add the rich, warm darks.*

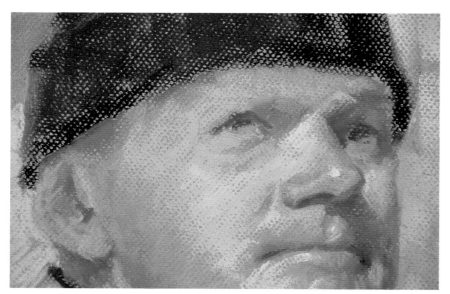

### 13 REFINING THE EYES AND EAR

*Add warm peach-colored middle tones around the eyes and forehead. Apply a light blue-gray to the lower portion of the irises.*

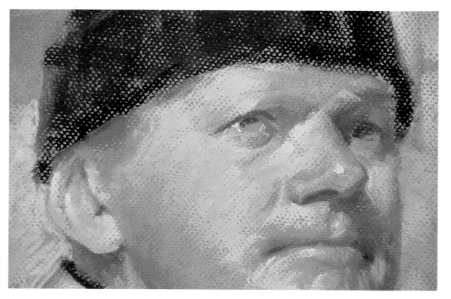

### 14 THE LIGHT VALUES

*The "white" areas of the model's right eye are actually light pink on the inside and lighter pink on the outside. Apply the lights to the ear. Start with the warm pinks, then work up to the highlights. Add a cool shadow under the sideburn.*

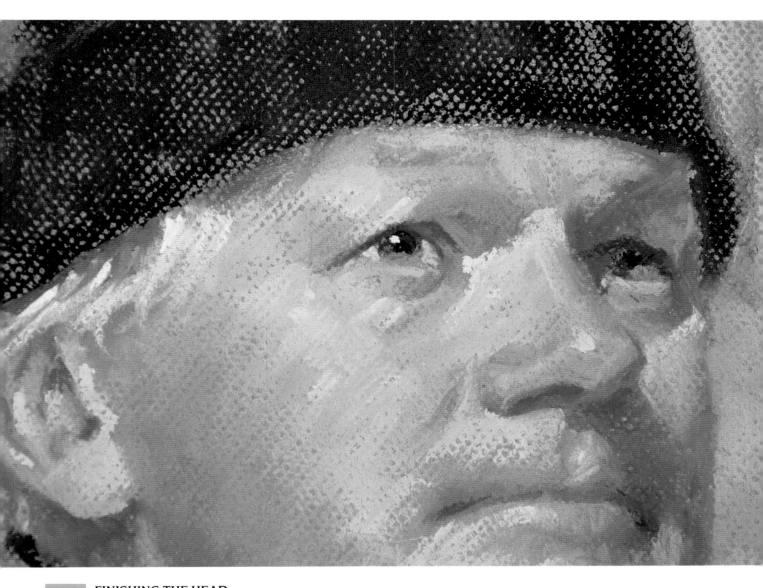

### 15  FINISHING THE HEAD

*Redefine the darks, including the black pupils and the dark red-browns of the upper lids. Now add the highlights in the eyes. Notice how the highlight falls between the pupil and iris. Use a very light umber color for the eyebrow on the light side of the head. The ear receives more warm darks. Add a middle-value umber for the shadow areas of the hair. An off-white color can be applied for the lightest areas of hair.*

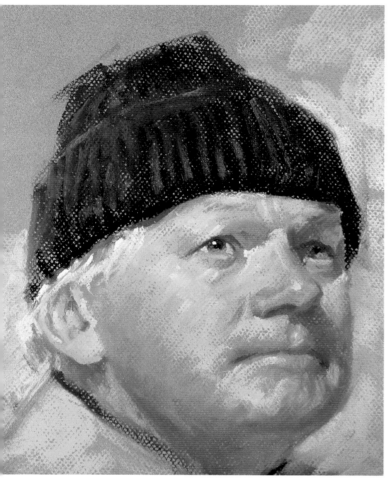

### THE HAT

**16** *Add a strong black around the bottom of the hat. Apply a middle-value purple that represents the ribbing of the hat. Don't try to draw every rib—just suggest some. Add some warm tones on the light side to break up the solid darkness of the hat.*

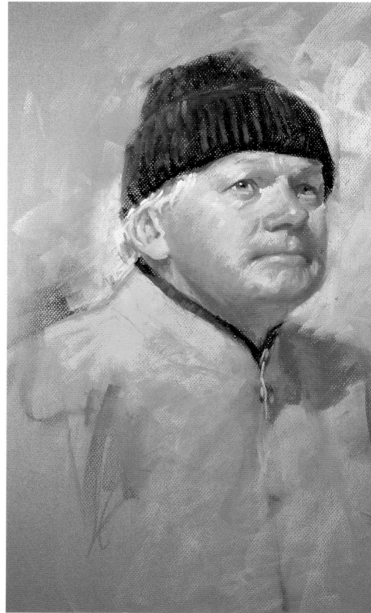

### THE SLICKER

**17** *For the collar of the slicker, first add black. Next, add a middle-value warm tone to the light area. Intensify the color of the slicker with brighter, deeper yellows. Bring some of the slicker color into the background for more harmony of color. Add brass buttons by first applying dark browns, followed by warm golds in the light areas. Add warm orange halftones to the fold areas of the slicker.*

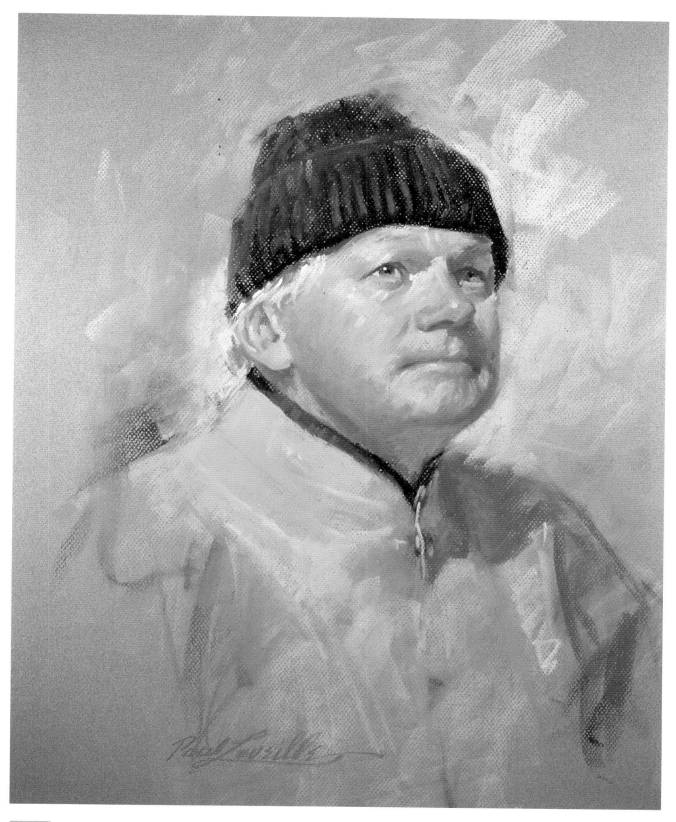

## 18 COMPLETING THE PORTRAIT

*Finally, add pale yellow highlights to the slicker.*

## DEMONSTRATION 5
# Young Girl With Dark Hair

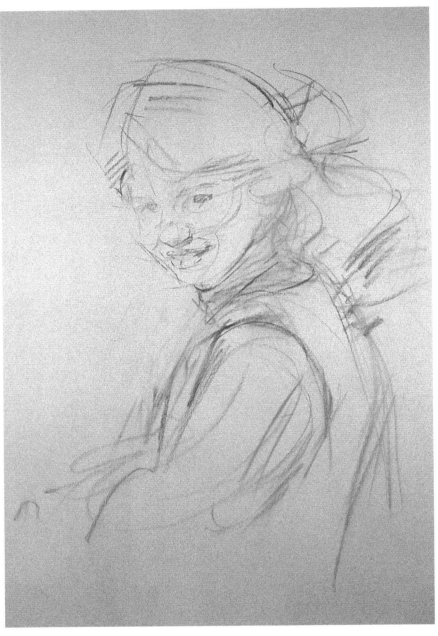

**1** **THE SKETCH**
*In this demonstration we will use very little, if any, blending to produce a more painterly-looking portrait. I've chosen a cool gray stock (Canson Mi-Teintes steel gray) that will go nicely with the dark—almost black—hair and white blouse of the model. On the smooth side of the paper, sketch the head and shoulders with a piece of medium-soft vine charcoal. You can achieve a pencil-type point on the end by rubbing the charcoal on a piece of sandpaper. When the sketch is completed, give it a light spray of workable fixative to prevent the charcoal from smudging when the light pastel colors are applied.*

**2** **THE FLESH TONES AND JUMPER** ▶
*As you work on the skin tones, keep in mind that this model has a darker, more olive complexion than the models in previous demonstrations. Scumble a raw sienna tone lightly over the face. Add a pink tone to the cheeks and nose area. Next, lightly add broad strokes of red to the jumper.*

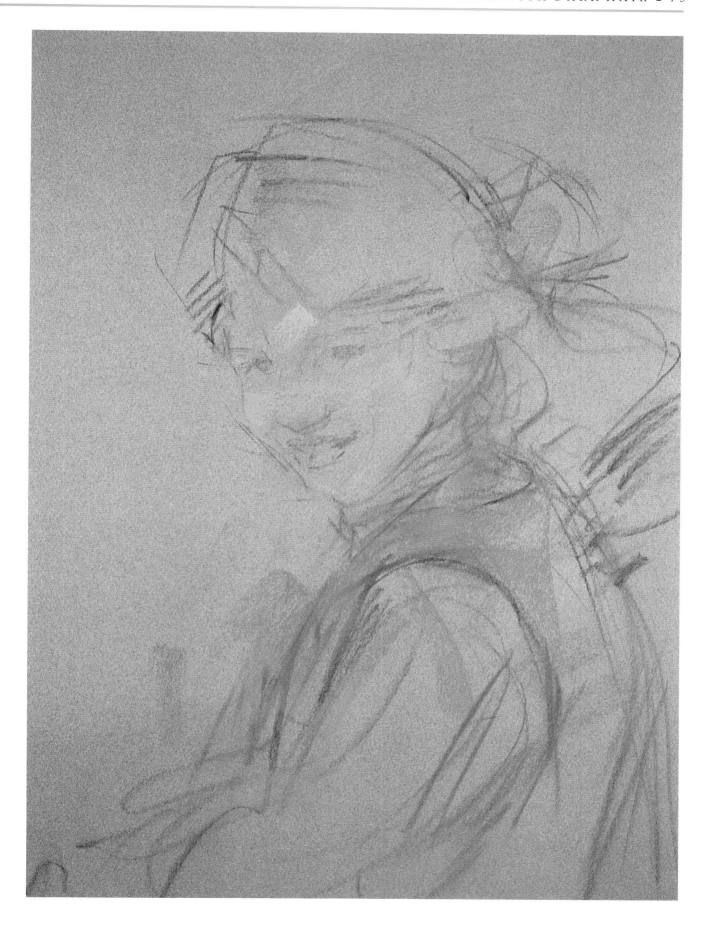

**3** **DARKER FLESH TONES**
*Apply a raw umber tone to the lower portion of the face. Loosely, without much pressure, apply a burnt sienna color to the cheeks, nose and forehead.*

**4** **THE DARK SHADOWS**
*Use a cool red-brown to define the dark shadow shapes.*

**5** **MORE DARK SHAPES** ▶
*Continue to work on the darks by adding deep rich brown and Ivory Black for the hair. Use a purple-brown for the darker shadows of the face and to loosely indicate the eyes.*

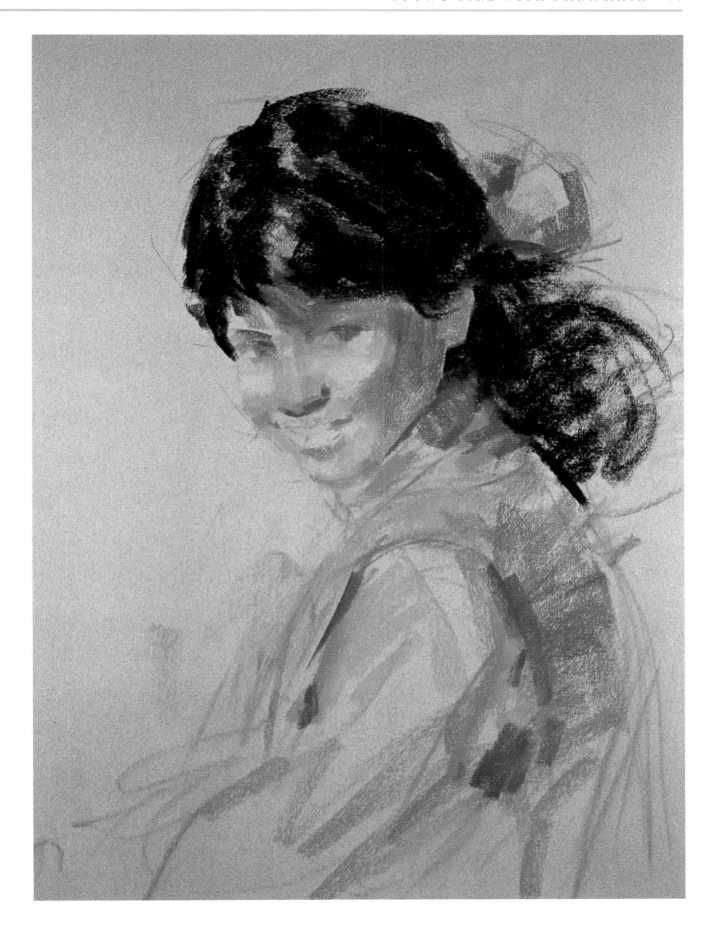

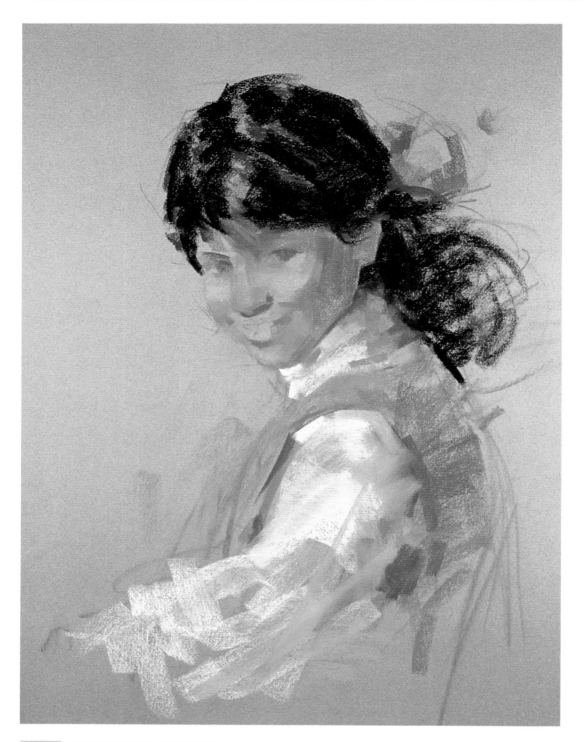

### 6 THE BLOUSE AND CHIN
*Suggest the blouse with a cream color for the light areas and a darker putty tone for the shadow areas. Build the chin area with halftones of light olive and sand. Use a darker olive under the lip and chin.*

### 7 REFINING THE FLESH TONES AND JUMPER ▶
*Add a ruddy brick color to the cheeks and nose. Add a rust color to the lower jaw line and under the nose and chin to indicate reflected light. Use a light gold tone for the forehead and under the eyes. Add a brighter cool red to the jumper and hair bow.*

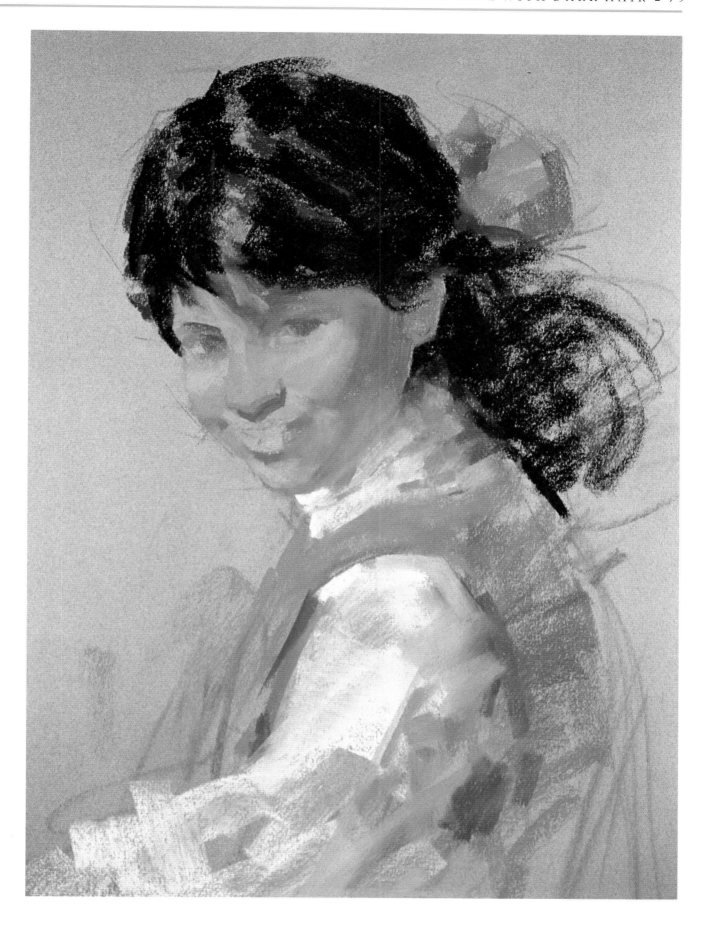

### 8 THE MOUTH AREA AND JAW

*Suggest the teeth with a putty color. (Teeth and the "whites" of the eyes are never pure white.) Set the jaw apart from the turtleneck jersey with a dark red-brown. Suggest the lips with a warm rust color. Use a yellow ochre color for the light areas around the lips.*

### 9 CONTINUE BUILDING THE MOUTH AREA

*Indicate the ends of the mouth with a dark red-brown. Soften these areas with lighter red-browns. Indicate the shadows on the teeth with a raw umber tone. Also add some Yellow Ochre to the bright areas of the cheek.*

### 10 THE LIPS, CHEEKS AND NOSE

*Give the lips a light pink highlight. Use a maroon color on the side of the nose, on the cheeks and under the eyes. Add the same warm red tone used for the lips to the top of the nose and cheeks. Add a light gold to the bridge of the nose.*

### 11 THE HIGHLIGHTS

*Add ivory highlights to the bridge and tip of the nose, using one crisp stroke to add the highlight on the tip of the nose. Using the broad side of the pastel, apply a softer application of ivory to highlight the cheek. Add a light orange to the cheeks and forehead.*

### 12 THE EYES
*Use a sand color to fill in the whites of the eyes. Broadly indicate the upper lid with a dark warm brown. Paint the upper lashes and irises with deeper brown.*

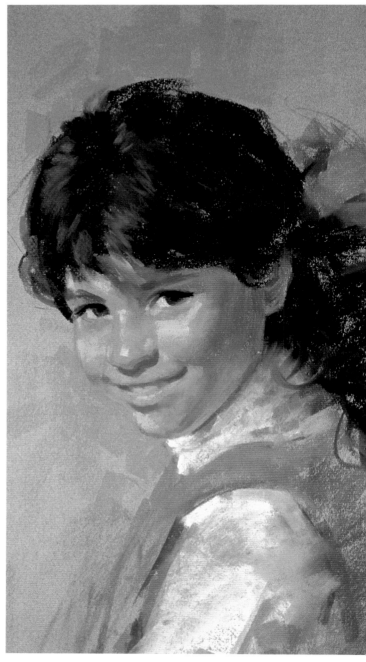

### 13 THE EYES AND HAIR
*Use Ivory Black for the pupils and darkest parts of the upper lashes. Use a brown tone for the eyebrows. Apply a cool red-brown to the hair, followed by areas of lighter brown.*

### 14 COMPLETING THE PORTRAIT ▶
*Add the highlights to the hair by first applying cream-colored strokes, then applying light blue over the cream. Stroke black back into the highlight areas. Use the sharp edge of a sand-colored pastel to create the highlight for the model's left eye. Give the other eye a darker raw sienna highlight. Finally, redefine the jersey with crisp strokes of light cream.*

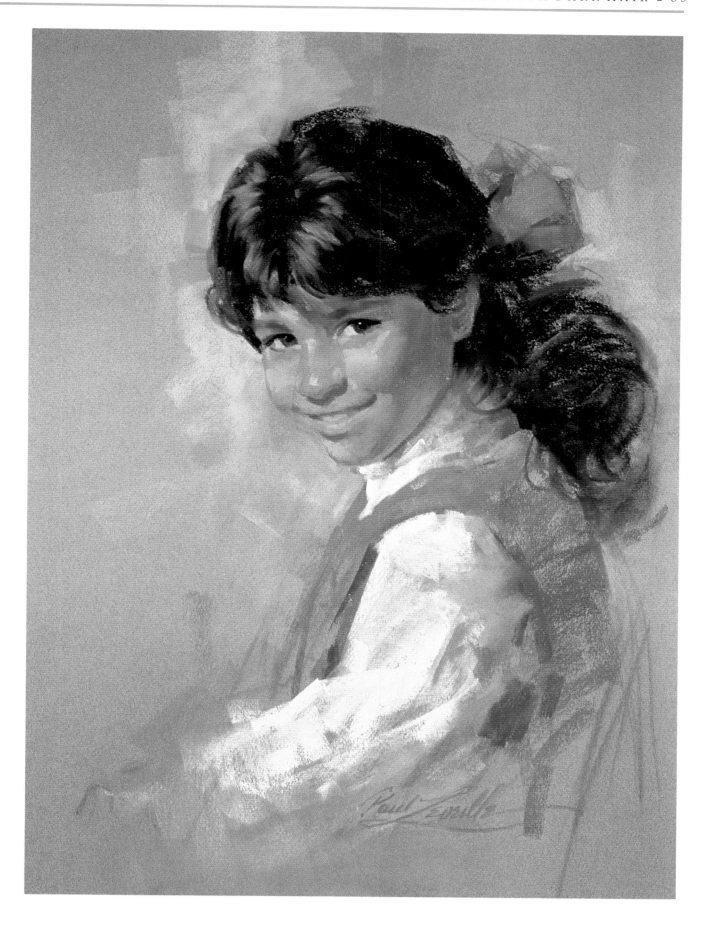

## DEMONSTRATION 6
# Blonde Girl With Red Jacket

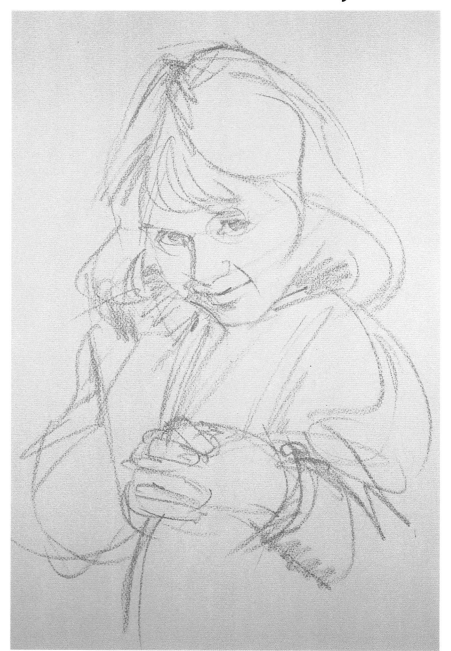

**PALETTE**

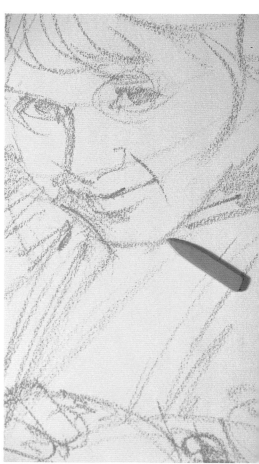

**1** **THE SKETCH**
*For this portrait, I'm using the smooth side of a sheet of Canson Mi-Teintes cream. This color will contrast nicely with the young girl's blonde hair and red jacket. Sketch the head and hands in with a sharpened piece of light purple hard pastel. To create the point, rub the end of the pastel on a sandpaper block.*

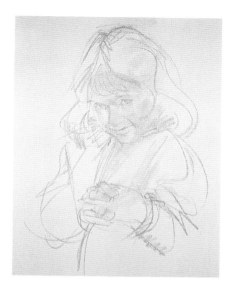

**2** **THE BASIC FLESH TONE**
*Loosely add a light pink tone to the face.*

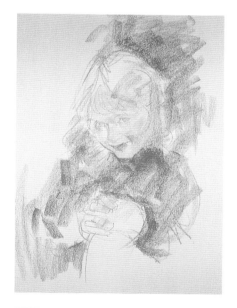

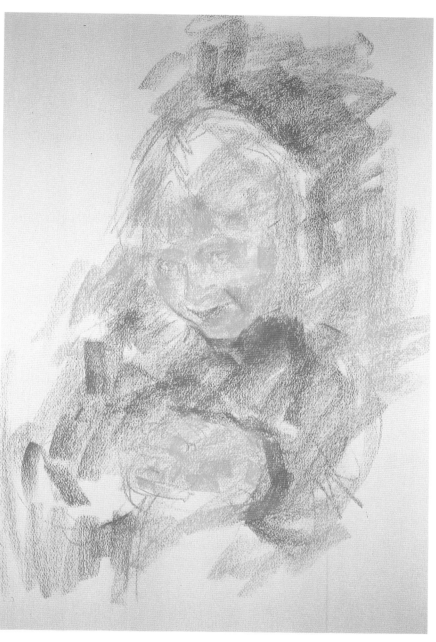

**3** **THE BRIGHT REDS**
*The bright red jacket will tend to dominate this portrait. Put this color in now to make judging the face colors easier. Add a little of this color to the background and lips.*

**4** **MORE FLESH TONES**
*Add golds to the lower portion of the face, cheeks, hair and hands. Add stronger pinks to the nose and cheeks.*

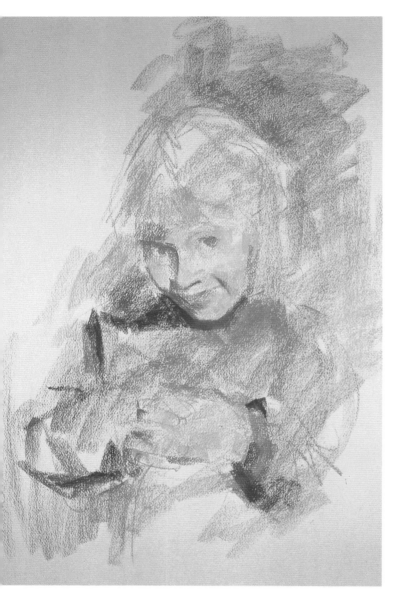

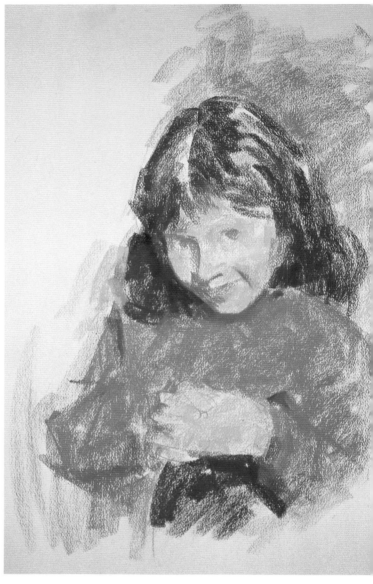

**5** **THE SHADOW SHAPES**
*Use a dull purple tone on the side of the nose, eyebrows and hands. Give the chin in shadow a reddish purple tone, and suggest the jacket in shadow with a deep, dark red-purple.*

**6** **MORE DARKS**
*Use red-browns and raw sienna tones for the hair. Also add red-brown shadows under the hands and on the back of the chair.*

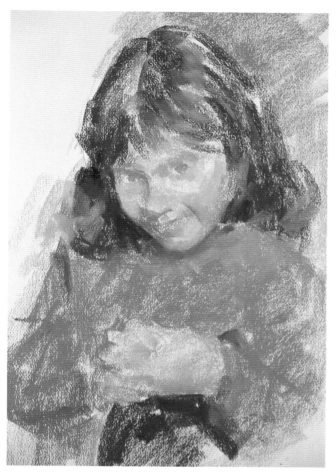

**7** **THE HALFTONES**
*Add a raw sienna tone for the chin and cheek. Add a pale orange to the chin, hair, hands and under the eye.*

**8** **THE LIGHT TONES**
*Shape the lighter areas of the mouth with pale gold tones. Also use this color on the cheekbone, nose and hands. Work a light pink into the pale gold on the nose and cheeks.*

### 9 ADDING DETAILS

*Redefine the nose shadow. Indicate the overall shape of both lips with a warm red tone. Also use this color to suggest the reflected light under the chin. Loosely suggest the fingers by adding a warm brown tone on the edges.*

**11** **THE LIPS**
*Add a light pink to
the lower lip.*

**10** **THE MOUTH DARKS**
*Further define the mouth by add-
ing a red-purple for the dark area
between the lips.*

**12** **THE HIGHLIGHTS**
*Finally, add a very light pink highlight on the lower lip.
Add a highlight on the nose with a pale peach tone, using
a softer pastel (Great American Art Works brand). A harder pastel
would tend to dig color out, while the softer pastel will lay on top.*

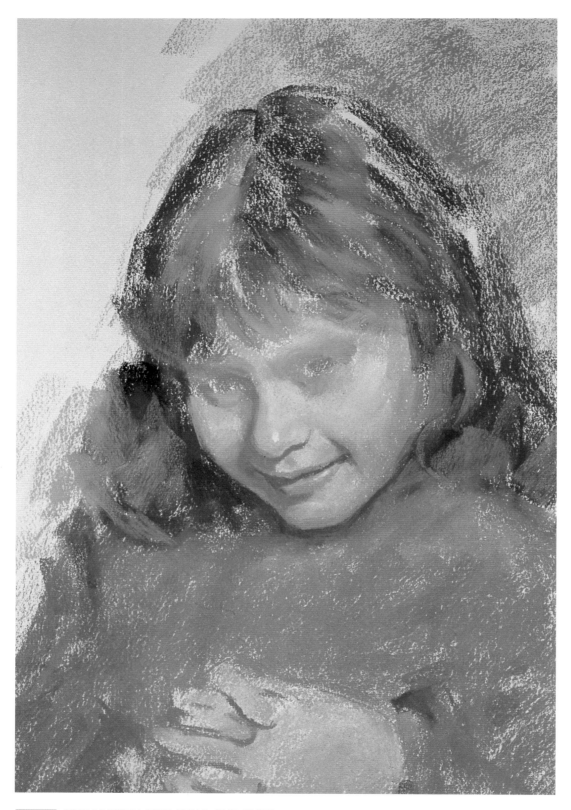

**13**

### THE JACKET, EYE AREA AND HAIR

*Add more purple shadows to the jacket. Build the shapes around the eyes with
cool lavenders, golds and oranges. Add oranges and lavenders to the hair.*

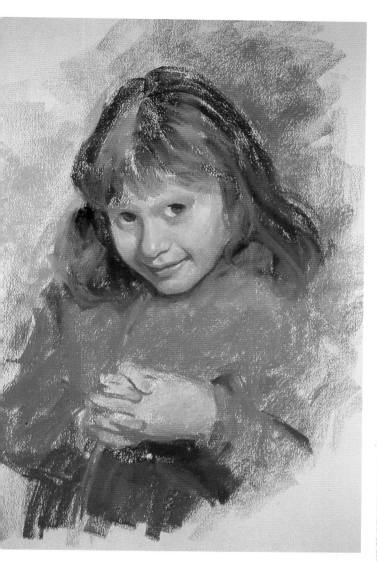

**14 THE EYES, BACKGROUND AND JACKET**
*Suggest the eyes with a red-brown color. Put in the upper portion of the iris with a dark, rich brown. Use a cream color for the whites of the eyes. Give the background and jacket some light blue tones.*

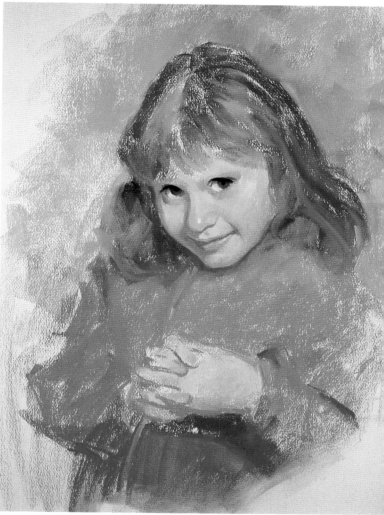

**15 THE EYES AND BACKGROUND**
*The red background seems too distracting. Soften this area with the addition of pinks, golds and light blues. Put in the very upper portion of the eyelids with a warm dark brown. Add the lashes and pupils with black. The shadow areas in the whites of the eyes are a dull purple.*

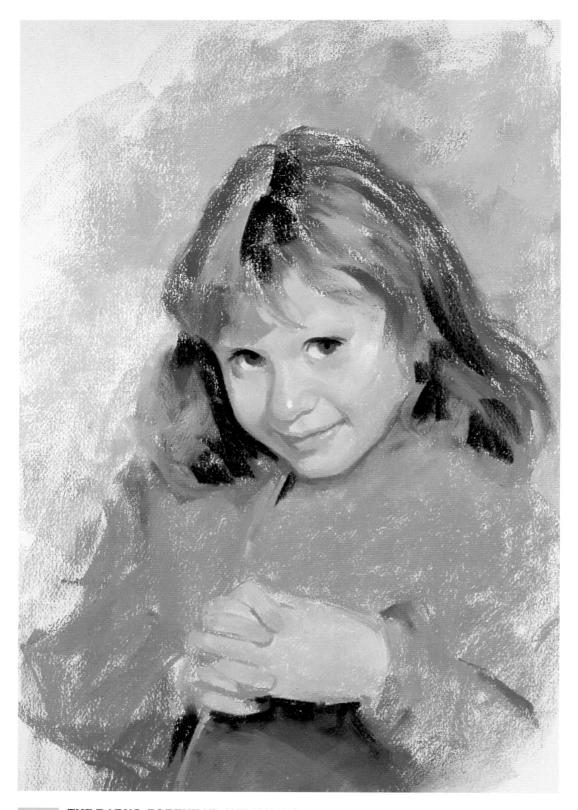

### THE DARKS, FOREHEAD AND HANDS

**16** *Let the blacks of the eyes dictate the need for other darks in the portrait, such as the darkest areas of the hair and under the hands. Add a lavender shadow to the forehead. Give the light areas of the forehead a yellow ochre tone. Add pinks and golds to the hands.*

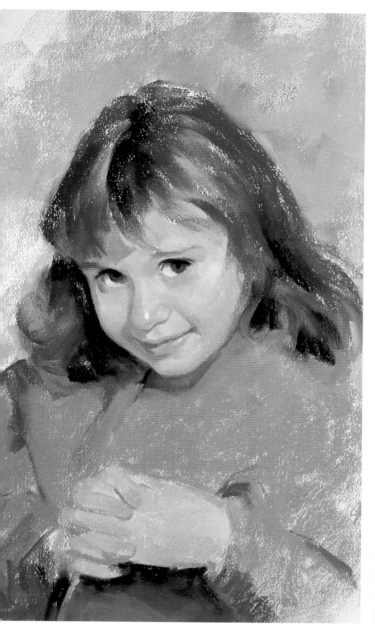

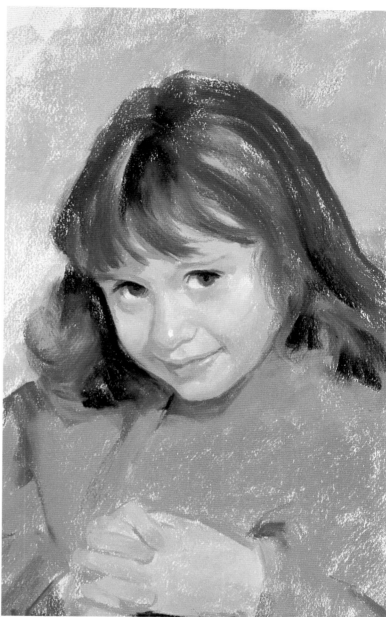

**17** **THE EYEBROWS, HAIR AND JACKET**
*Indicate the eyebrow on the light side with a raw sienna tone. Soften each end by rubbing with a finger. Use a dark warm brown for the eyebrow on the shadow side. Stroke a red-brown color into the black areas of the hair. Clean the pastel stick after each stroke to keep colors from getting muddy. Strengthen and define the jacket shadows.*

**18** **THE BANGS AND EYES**
*Give the bangs a warm brown tone. Add a light pink to the shelf on the lower lid of each eye.*

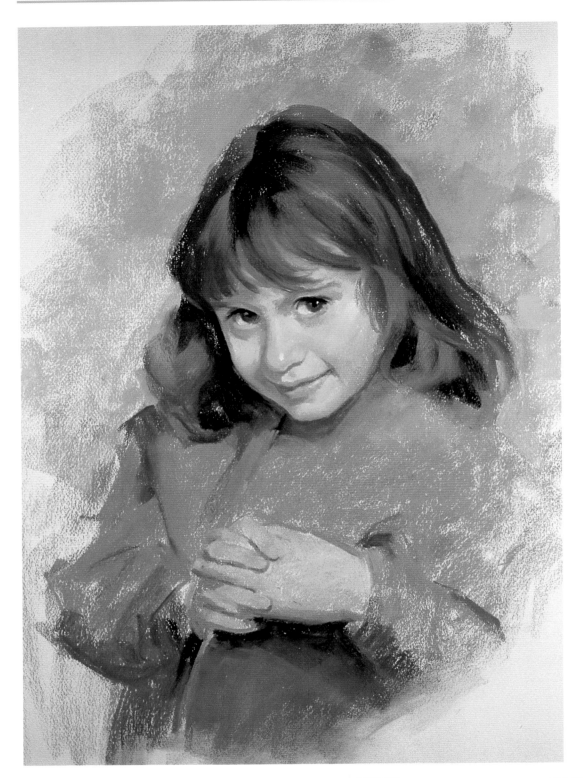

**19** **THE LIGHT TONES AND REFLECTED LIGHTS**
*Add a raw sienna tone to the light areas of hair. Suggest fingernails with a light tan tone. Use a red-brown to suggest shadows under the fingers. Put the brightest highlight in the eye with the edge of a light cream pastel. Add a cool, reflected light to both eyes with a blue-gray pastel.*

**20** **COMPLETING THE PORTRAIT** ▶
*Stroke in the brightest highlights in the hair with a yellow ochre color. Soften and blend these bright highlights with a Raw Sienna pastel. Add Yellow Ochre to the jacket. Add cream highlights to the fingernails. Darken the nose shadow. Suggest trim on the jacket cuffs with strokes of light blue, red and cream.*

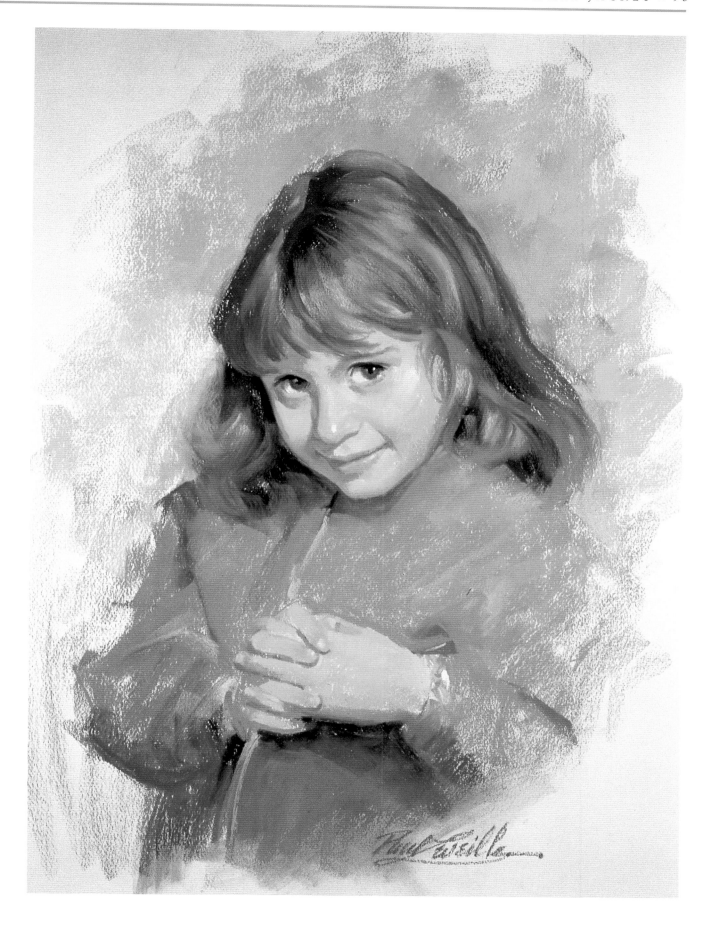

## DEMONSTRATION 7
# Man on Dark Background

### PALETTE

### TIP

Get more variety in your strokes by padding the back of your paper. Do this by adding a dozen or more sheets of paper behind the sheet you're painting on.

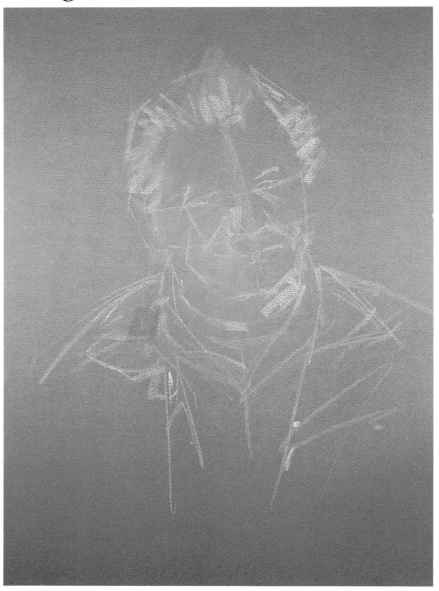

**1** **THE SKETCH**

*This portrait is done on the rough side of a sheet of Canson Mi-Teintes ivy. Using a dark background color can be challenging, as you essentially reverse the process used when beginning with a light background. Start by sketching directly with pastel. Several colors are used to develop the sketch. The dark, ruddy tone represents the darker value areas in the portrait.*

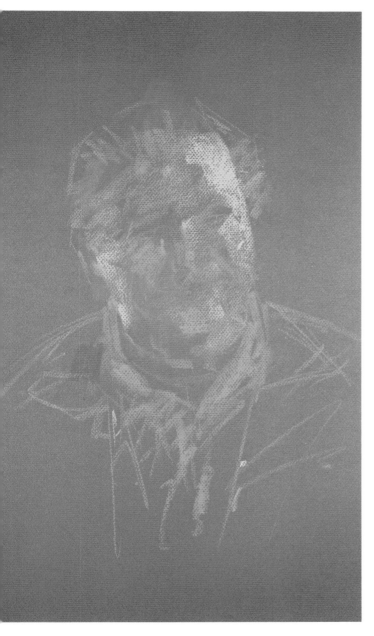

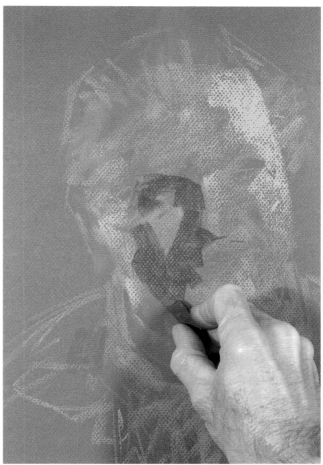

### 3 THE BIGGEST DARK SHAPES

*Add the biggest dark shapes broadly with a deep red-brown color.*

### 2 DEVELOPING THE DARK AND LIGHT SHAPES

*Starting with the light side of the model's face, loosely apply a gold color for the brightest areas. Add a rust color, a little darker in value than the gold, to the center of the forehead and chin. Finally, use a burnt sienna tone for the shadow side of the forehead, nose, cheek, chin and shirt areas. At this stage, don't be concerned about details. Concentrate on developing the big dark and light shapes.*

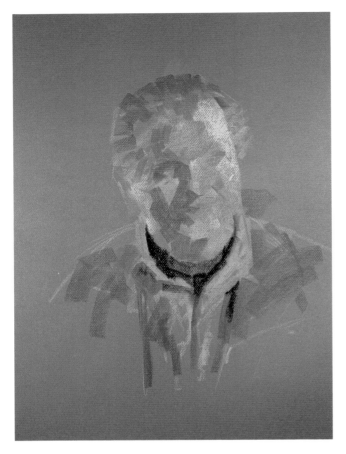

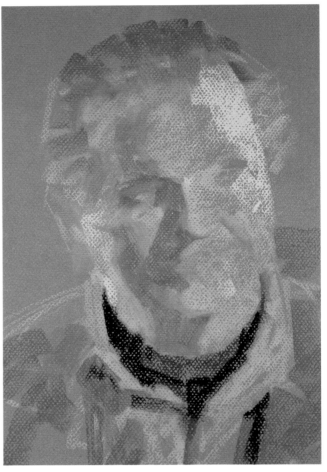

**4** **CONTINUING THE DARKS**
*Put the remaining large dark shapes in, using a deep olive green for the darks of the hair and a deep violet and black for the T-shirt.*

**5** **THE MIDDLE VALUES**
*Your next goal is to establish values and colors that fall between the dark and light areas, creating the appearance of rounded forms. Use a Venetian red tone to achieve this effect. Use a lighter tone of burnt sienna for the bridge of the nose, cheeks, chin and neck. It's best to use light-to-medium pressure with the pastels at this stage of the painting. As the painting progresses and shapes are more defined, bolder strokes can be used.*

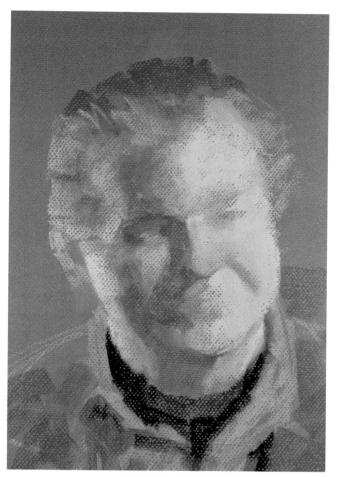

### 6 FURTHER DEFINING THE LIGHT SHAPES

*Define the light shapes even more with a light gold tone. Next, use a raw sienna color on the light side of the forehead, mouth and chin area.*

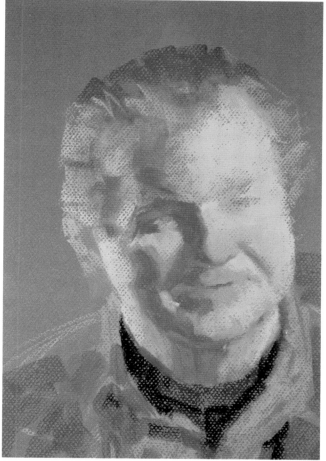

### 7 REDEFINING THE DARKS AND ADDING REFLECTED LIGHT

*Redefine the darkest areas with a deep reddish-brown. Apply a slightly lighter and warmer Venetian red color to the shadow areas under the nose, chin, eyelid and lip areas to suggest reflected light.*

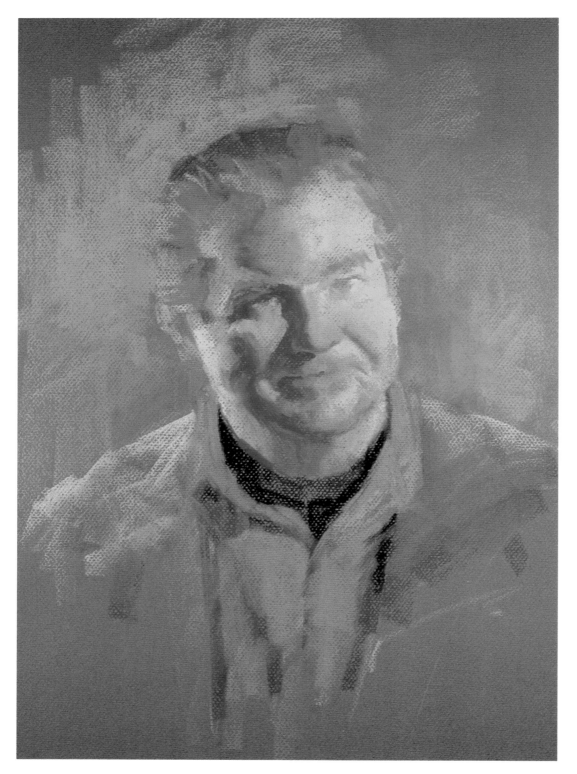

### 8 THE MOUTH AREA, BACKGROUND AND SHIRT

*Shape the mouth area with a raw umber tone. Also use this color to begin to build the eyebrows and hair. Apply a light blue to the background, followed by greens and purples. These cool colors will complement and contrast with the ruddy complexion of the head. Apply a light pea green to the shoulders and a Venetian red tone to the shirt.*

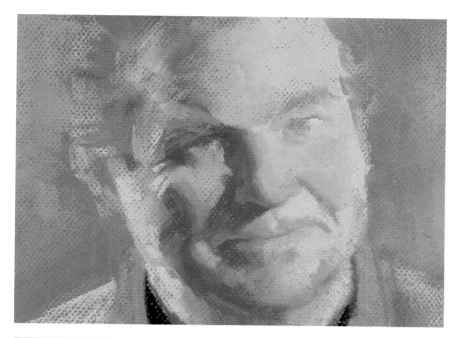

**9 THE LIPS**
*Use a cool, light brick color to suggest the lips.*

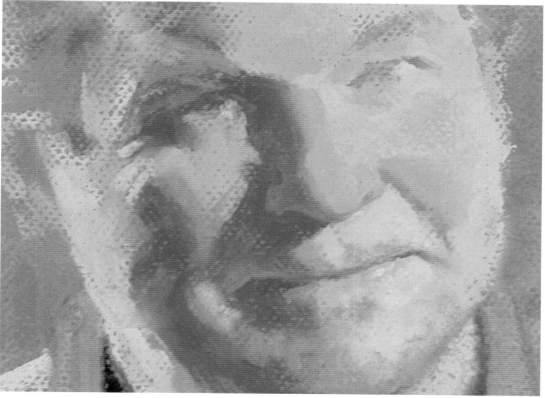

**10 FINISHING THE LIPS**
*Add a dark red-brown line between the lips, making it darker on the shadow side and lighter and warmer on the light side. Add a light pink highlight to the lower lip. Continue shaping the mouth area above the lips and around the chin with a light gray. This color can also be used to suggest facial hair.*

**11** **THE EYES**
Suggest the placement of the eyes using an olive green. Use a lighter pea green at the bottom of the irises to suggest the areas in light.

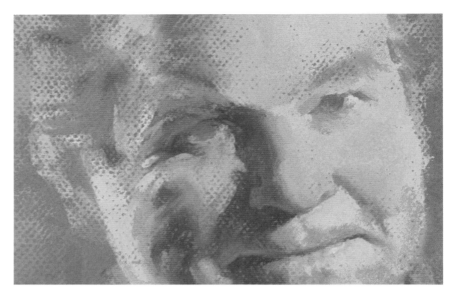

**12** **FINISHING THE EYES**
Continue to develop the eyes by adding a warm dark for the upper eyelid on the light side of the face. Add black pupils and shadows on the upper irises. Fill in the whites of the eyes with a light putty color—they will appear bright white in comparison to the darker values around them.

**13** **THE HIGHLIGHTS** ▶
Paint the light areas of the forehead with cream and light green tones. Also add cream colors for the cheek and nose highlights.

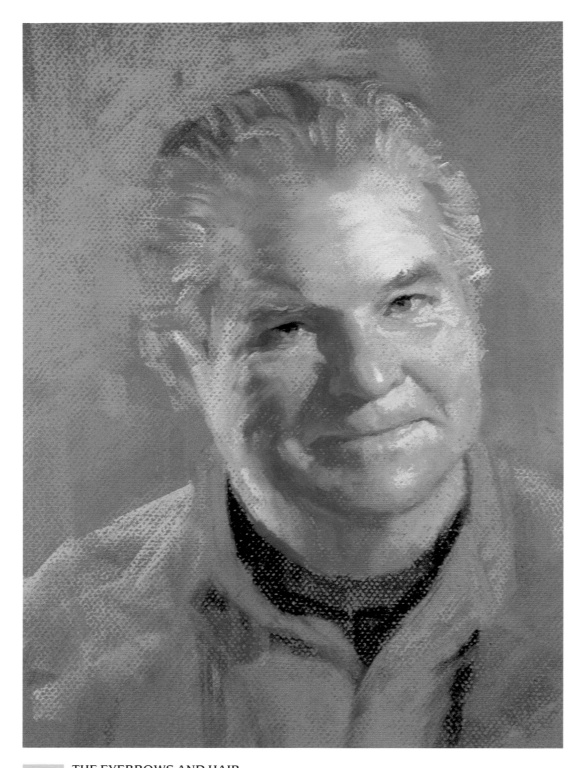

### 14 THE EYEBROWS AND HAIR

*Use a light brown tone on the light side of the eyebrows and a darker tone for the shadow side. Gently rubbing your finger along the beginning and end of the eyebrow on the light side of the head will soften these areas and make them appear more natural. Add a darker brown to the center of the eyebrows and a few thin strokes of Raw Sienna to suggest hair on the eyebrow in shadow. Also add some medium lights to the hair using the side of a tan-colored stick.*

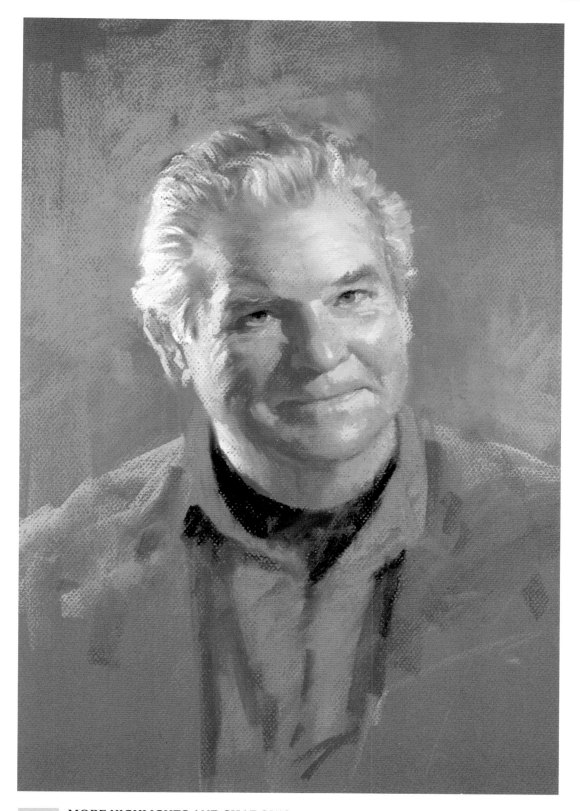

## 15 MORE HIGHLIGHTS AND SHADOWS

*Add warm ivory highlights to the hair with bold strokes. Apply cool pinks to the highlight areas on the side of the face. Add a warm ivory highlight to the cheek with a couple of quick, broad strokes. Define the T-shirt and shadows of the rust-colored shirt with dark strokes.*

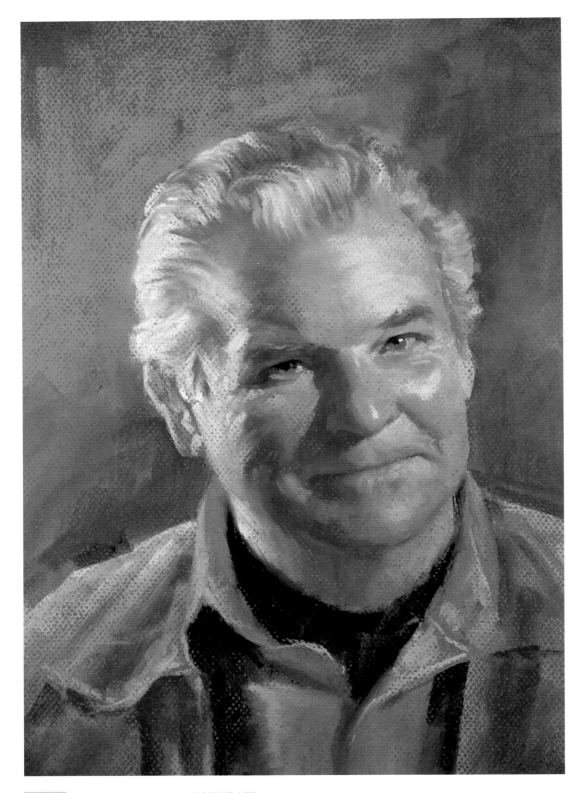

## 16 COMPLETING THE PORTRAIT

*Define the shoulders with sure, broad strokes of light green. Refine the darks and lights in the orange shirt. Add highlights to the eyes, making the light side highlight lighter than the shaded eye. Leave the portrait alone for a while, then take a second look and make any minor adjustments needed.*

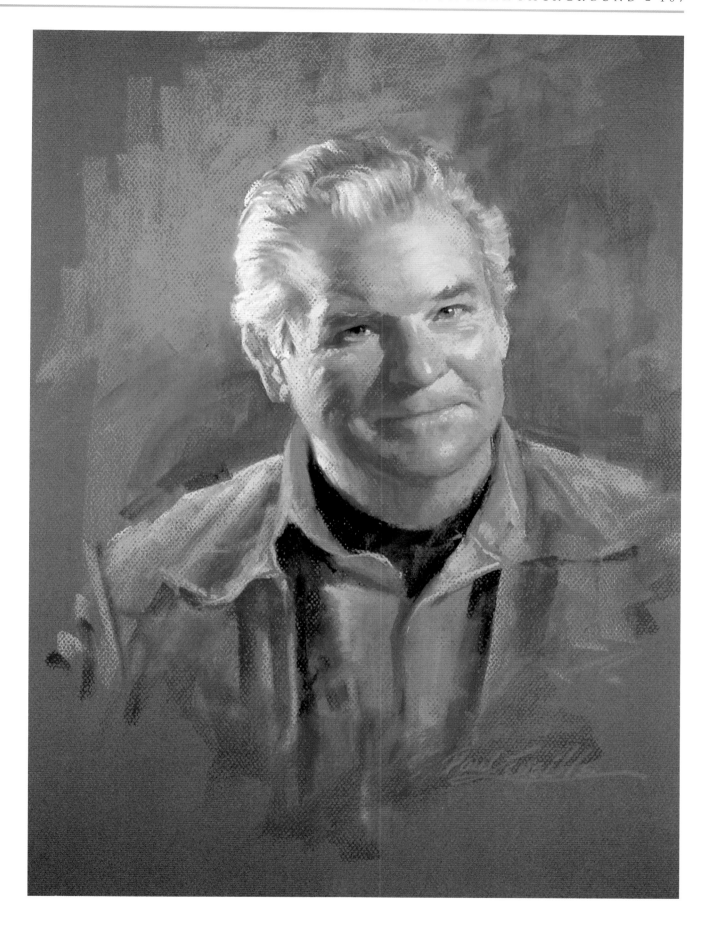

## DEMONSTRATION 8
# Woman With a Straw Hat - Over a Watercolor Wash

PALETTE

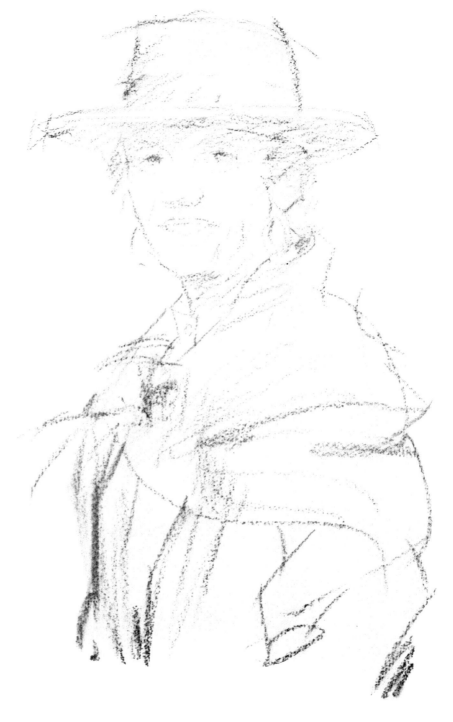

### 1 THE SKETCH
*For a different effect, try starting your pastel portrait with a watercolor wash. For this demonstration, I've selected a piece of 300 lb. Arches cold-pressed watercolor paper. Although the strongly textured surface of this paper helps to create some interesting effects, it can be challenging to work with. You may want to experiment with other brands and textures of watercolor paper to find the surface and degree of texture that appeals to you. Begin by sketching the head with a piece of medium-soft vine charcoal. When your drawing is complete, "dust" the surface lightly with a clean cloth to remove the excess charcoal.*

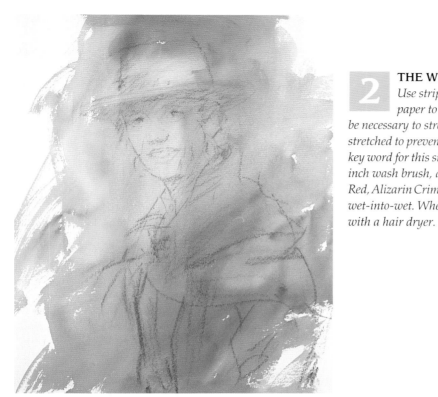

## 2 THE WATERCOLOR WASH

*Use strips of masking tape to secure all four sides of the paper to a board. If you're using 300 lb. paper, it won't be necessary to stretch it; lighter-weight papers may need to be stretched to prevent them from buckling when wet. Freedom is the key word for this step: With a large one and one-half-inch or two-inch wash brush, add bold washes of Cerulean Blue, Cadmium Red, Alizarin Crimson and Cadmium Yellow watercolors, working wet-into-wet. When you've applied all your colors, dry the surface with a hair dryer.*

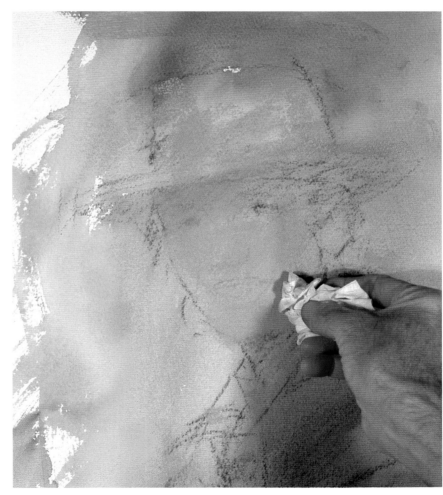

## 3 APPLYING PASTEL

*When the paper is dry, remove the tape and clip the drawing to the drawing board along with several sheets of paper in back of the drawing to act as padding. Add a light pink pastel color to the face and hat. Since the texture of this paper is so pronounced, use a tissue to blend the color over the surface.*

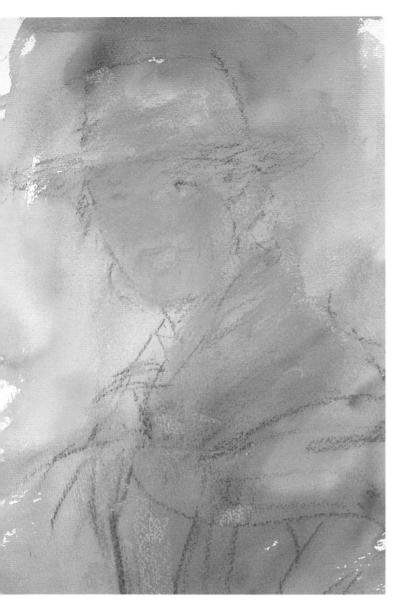

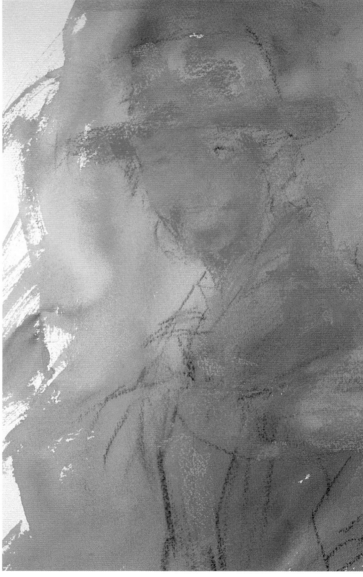

**4**
**DEEPENING THE PINK TONE**
*Add a deeper pink tone to the cheeks, lips, hat and scarf areas. Soften the nose and chin areas by rubbing them with a tissue.*

**5**
**THE LOWER FACE, HAT AND SCARF**
*Apply golds and light olives to the lower portion of the face, and also to the hat and scarf.*

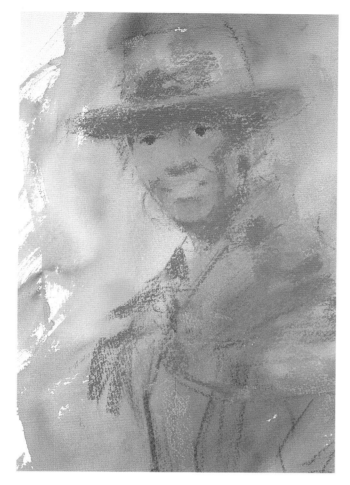

### THE SHADOWS

6

*Indicate the eye position with an olive green. Block in the large shadow patterns using a reddish purple tone. Notice how the shadows are connected from under the brim of the hat, the forehead, down the side of the cheek and under the chin.*

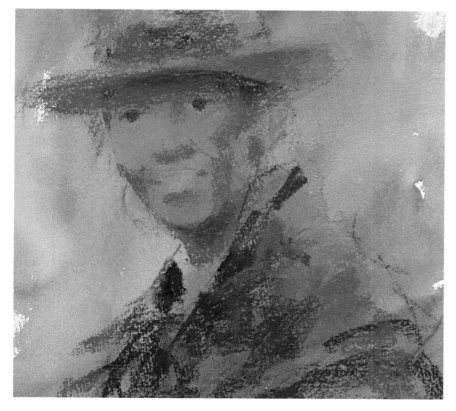

### MORE DARKS

7

*Apply a deeper purple to the scarf and under the chin and forehead. Add umber tones to the shoulder and lower portions of the face.*

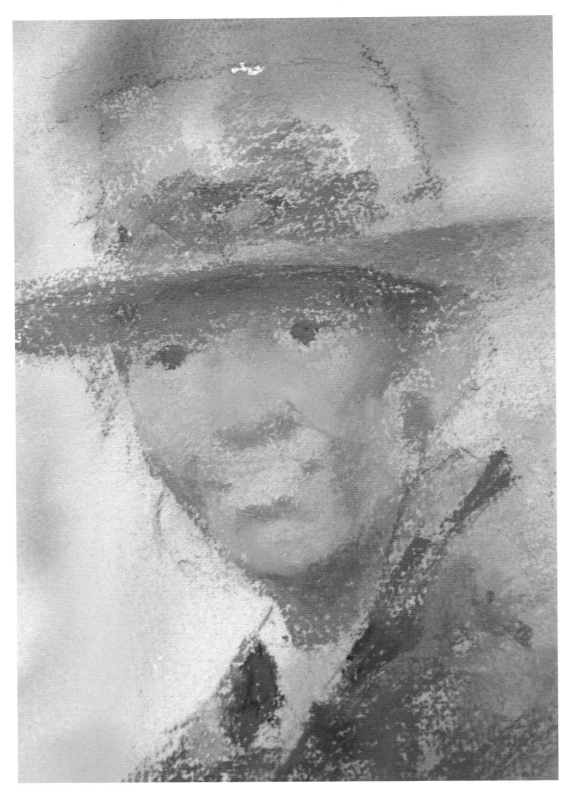

### 8   THE MIDDLE VALUES

*To make forms appear to turn from dark to light, middle-value colors are needed. Add a cool pink middle-value color to the cheek and nose area between the darks and lights.*

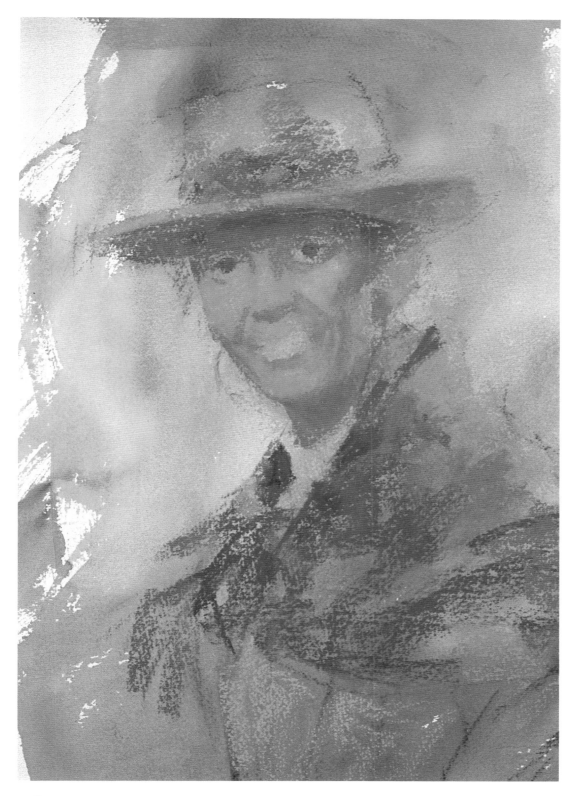

**9** **THE LOWER FACE, BLOUSE AND HAT**
*Start to shape the mouth and chin area before starting on details. Add gold for the brighter areas around the mouth. Apply a brick color under the chin and for the creases in the cheeks. Apply olives, golds and sand colors to the blouse and hat.*

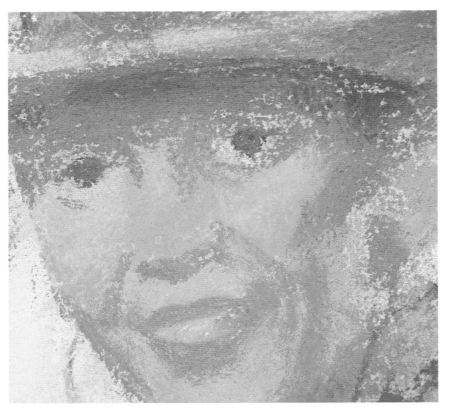

**10** **THE LIPS**
Lightly apply a cool red for the overall shape of the upper and lower lips.

**11** **THE LIPS AND CHIN**
Indicate the teeth with a sand color. Use a deep red-brown for the corners of the mouth. Add a cool, darker reddish purple for the shadow areas of the lips. Add pink strokes to the chin.

**12** **THE LIP HIGHLIGHTS AND NOSE**
Complete the highlight area in two steps: First, add a pink tone to the lower lip, then add the brightest highlight over the pink with a smaller mark of a lighter cool pink color. Strengthen the crease lines in the cheeks with a brick color. Add a cool violet tone to the side of the nose and under the eyes. Add pink to the tip of the nose.

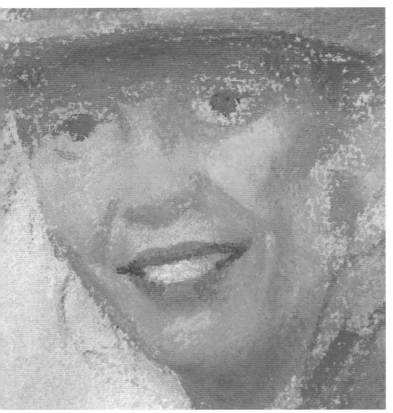

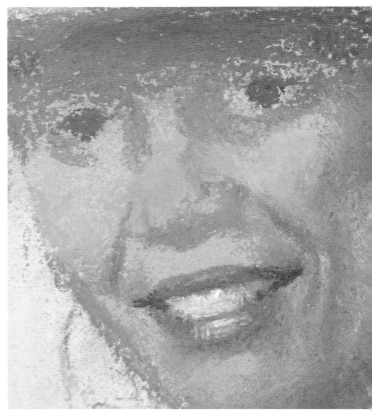

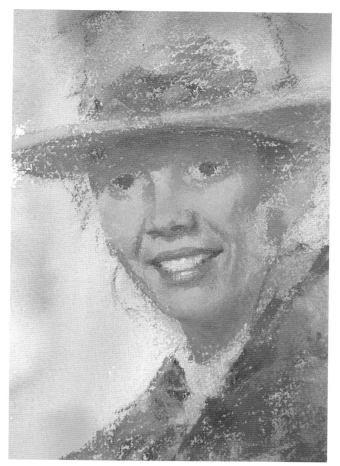

### 13 THE NOSE AND CHEEKS
*Further develop the nose by adding tones of pink and brick. Indicate the nostrils with a warm dark brown. Add light pink to the cheeks.*

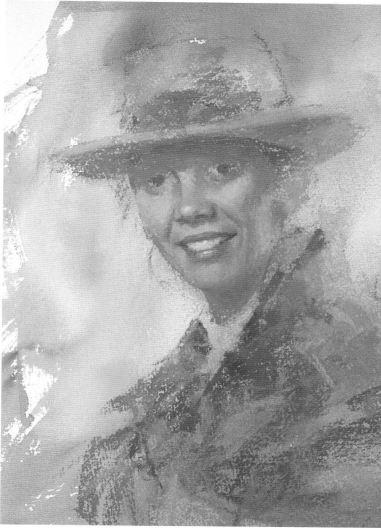

### 14 MORE DARKS
*Use a light cream color to add the highlight to the tip of the nose. Apply a burnt orange color to the underside of the hat brim, the shadow side of the face and the scarf. Apply lavenders under the eyes and to the hat band.*

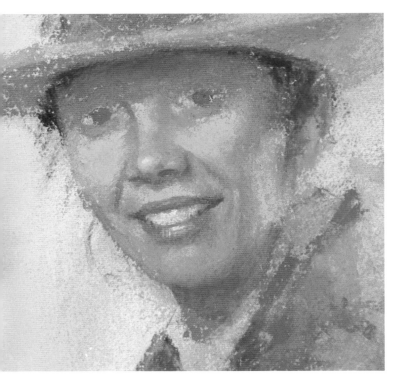

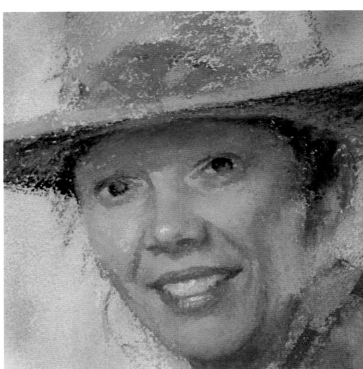

**15** **THE EYES AND DARKS**
*Add a light sand color for the whites of the eyes. Apply more lavender tones under the eyes. To add contrast to the warm skin tones, apply a light blue to the cheek, the side of the nose and the mouth. Indicate the hair with dark brown. Deepen the shadows on the forehead and under the chin. Use a red-purple for the ear darks.*

**16** **THE EYES AND HAT BRIM**
*Use a light olive color for the inside of the irises and a dark olive for the rim. Indicate the upper lids with a warm brown. Deepen the under part of the hat brim with tones of dark green and brick.*

**17** **COMPLETING THE EYES**
*Use Ivory Black for the pupils and upper lashes. Soften the ends of the lashes a bit with a dark brown. Due to the coarseness of this paper, small areas like the eyes will sometimes need to be blended with a tortillion to achieve accurate details. Deepen the forehead shadows with a dark red-purple. Apply a deep rust tone to show reflected light and to add depth.*

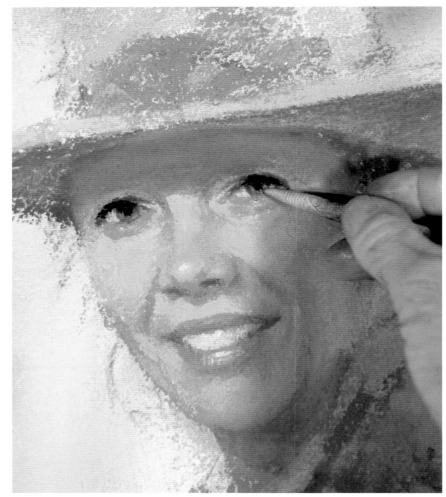

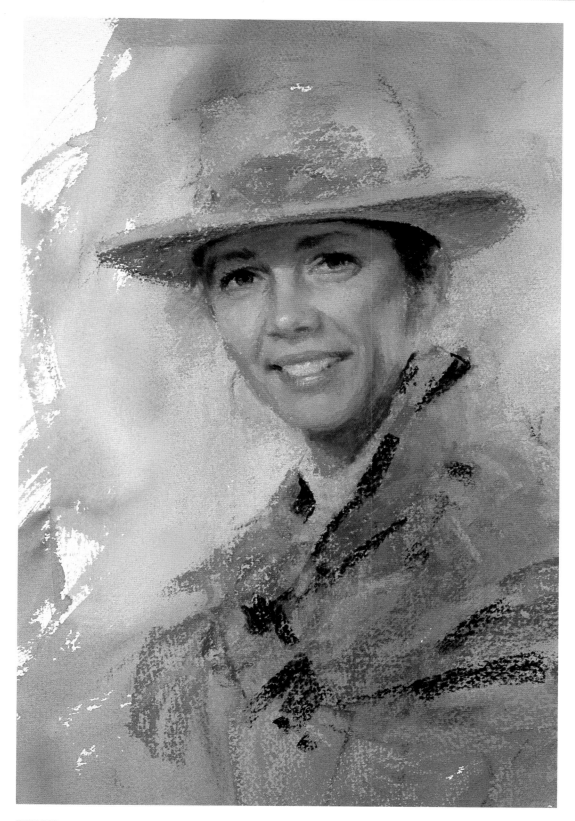

### 18 THE EYEBROWS AND OTHER DARKS

*Indicate the eyebrows with a brown tone. Keep them soft by blending them with your finger. Strengthen the dark areas in the hair, nostrils and sides of the mouth. Add subtle halftones around the eyes.*

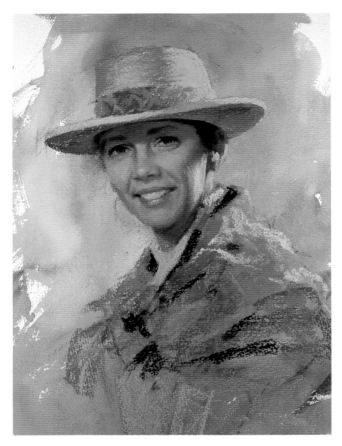

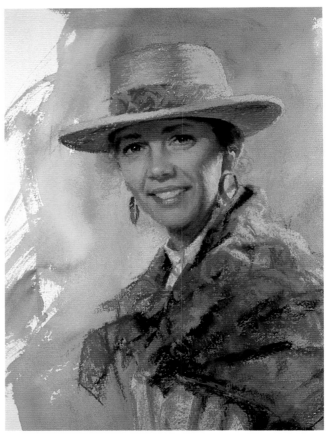

**19 THE LIGHT AREAS**

*For the lightest areas of the hat, cheek, neck and scarf, apply a light cream color. Add warm browns and golds to the hat rim and a putty color to the blouse.*

**20 THE EYE HIGHLIGHTS AND CLOTHING**

*Use a cream color for the eye highlights on the light side. Use a slightly darker value of sand on the shadow side. Darken the shadow under the nose. Apply darker tones of warm brown, olive and purple to the earrings. Apply dark browns, golds and greens to the scarf. Add more light putty color to the blouse.*

**21 COMPLETING THE PORTRAIT** ▶

*Complete the earrings with crisp strokes of pink and cream for highlights. Apply a light ivory color to the brightest areas of the hat, and add any final touches required.*

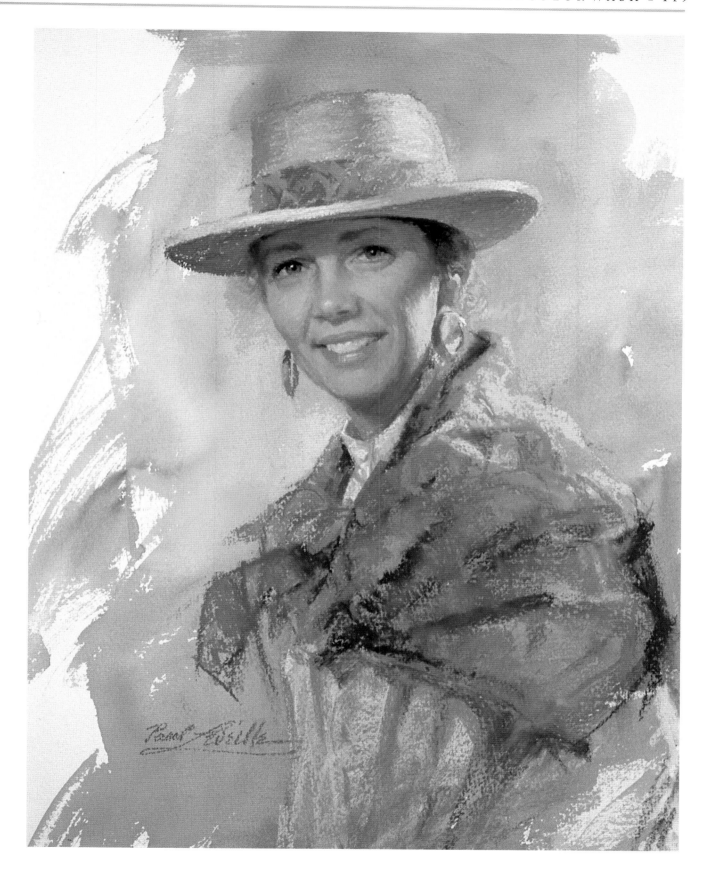

# Gallery

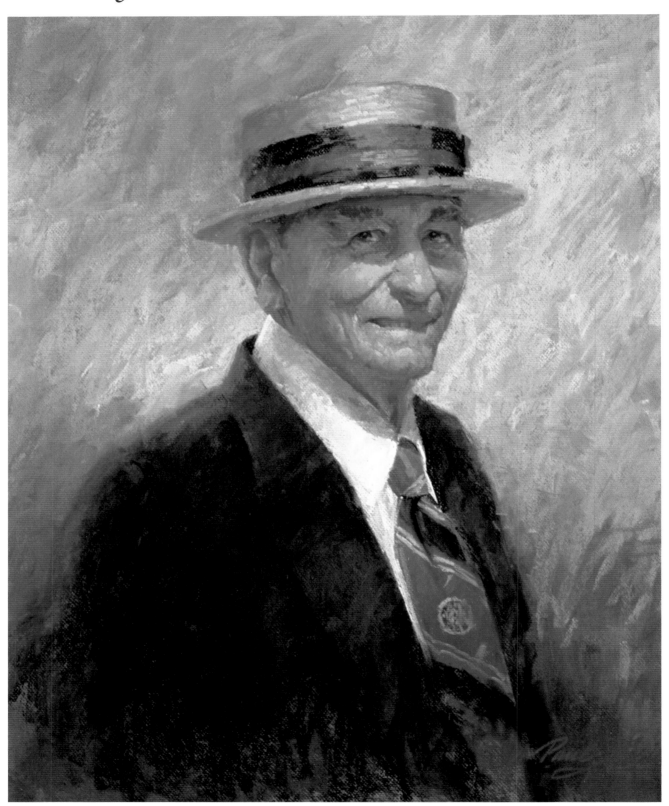

**SEAVER RICE,** *25″ × 30″ (63.5cm × 76.2cm)*

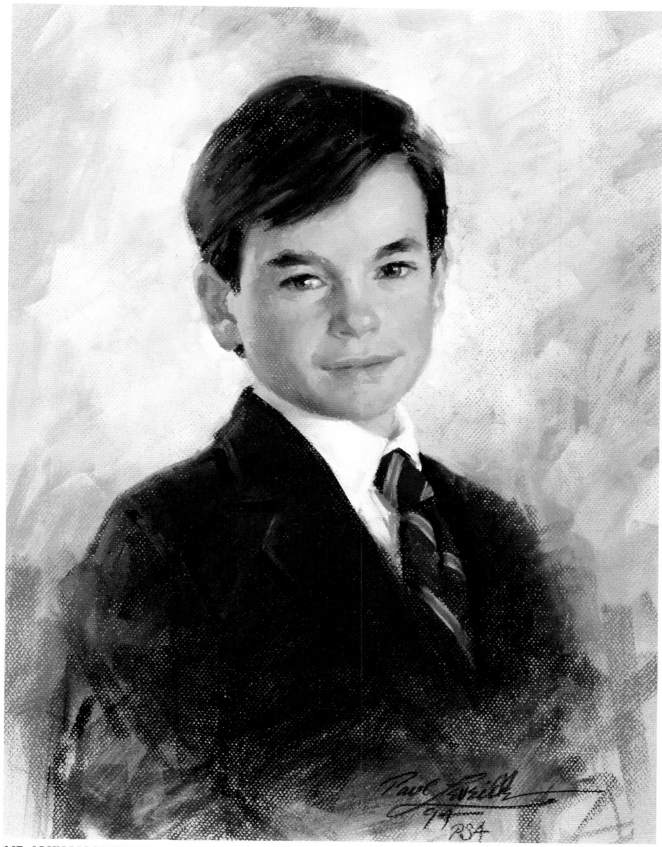

**MR. JOHN MCCONNELL,** *22″×17″ (55.9cm×43.2cm)*

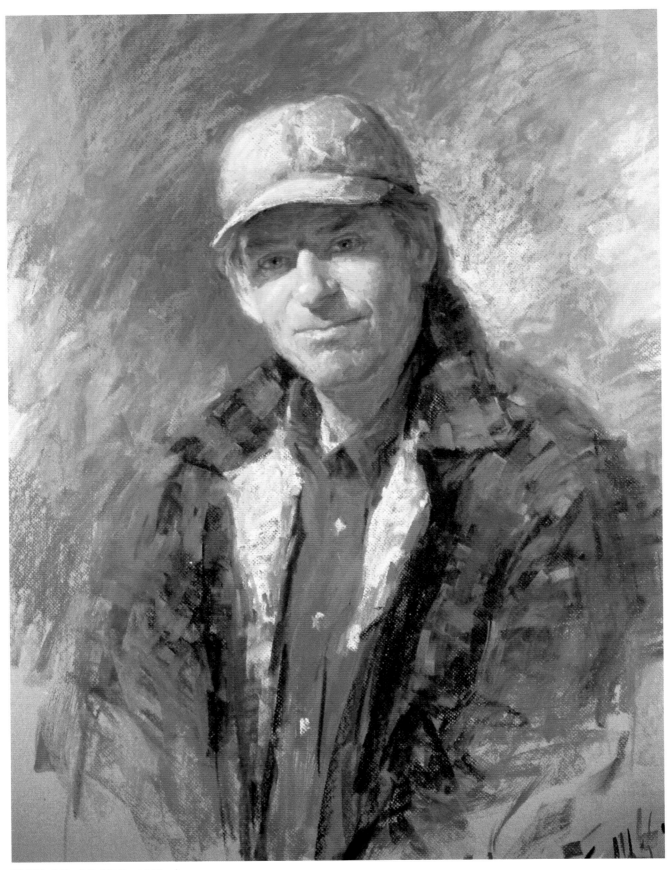

**JACK,** *31" × 24" (78.7cm × 61cm)*

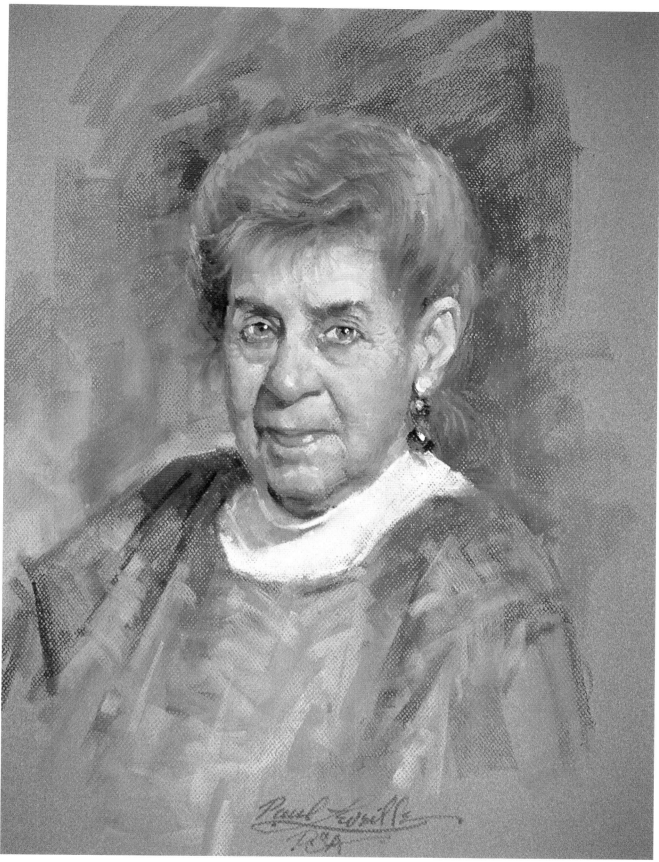

**ANTIE,** *23" × 18" (58.4cm × 45.7cm)*

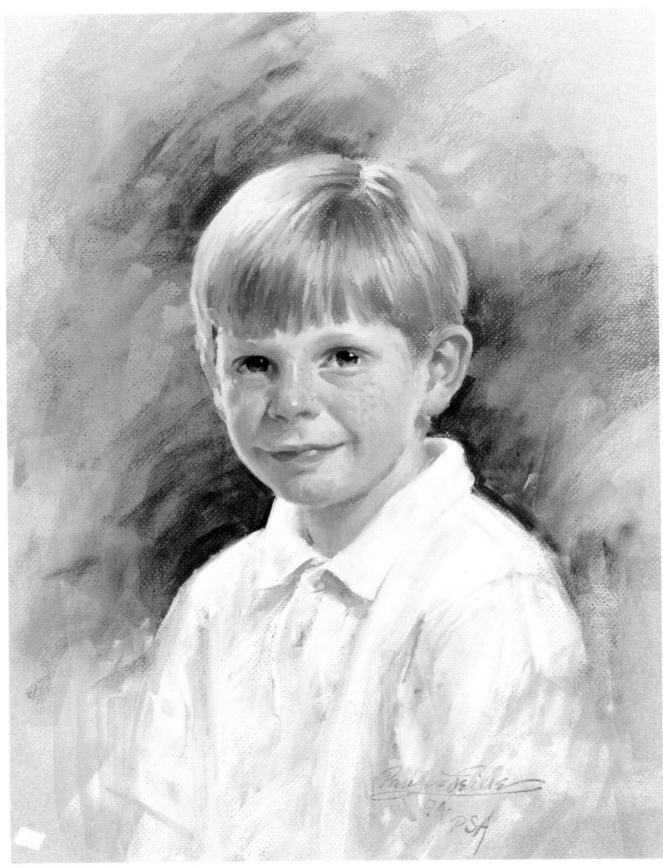

**TEDDY,** *22″ × 17″ (55.9cm × 43.2cm)*

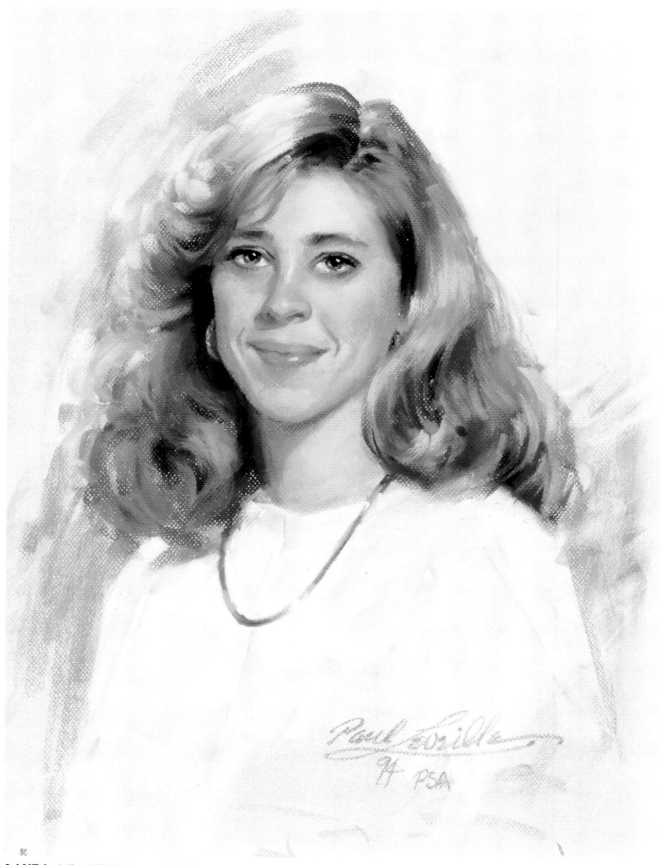

**LAURA,** *22″ × 17″ (55.9cm × 43.2cm)*

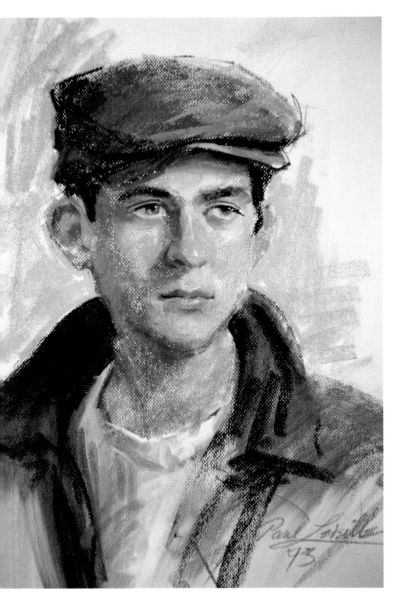

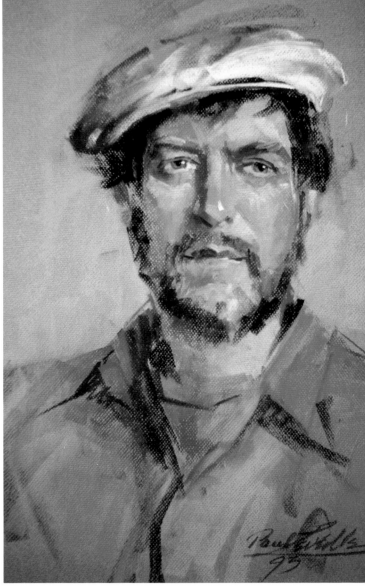

**BROWN CAP,**
*23" × 18" (58.4cm × 45.7cm)*

*These two portraits were done as workshop demonstrations. Note that the strokes are looser and less controlled than some of the previous formal portraits, adding character and spontaneity to the portraits.*

**DIX,**
*23" × 18" (58.4cm × 45.7cm)*

# INDEX